Living in the Sun

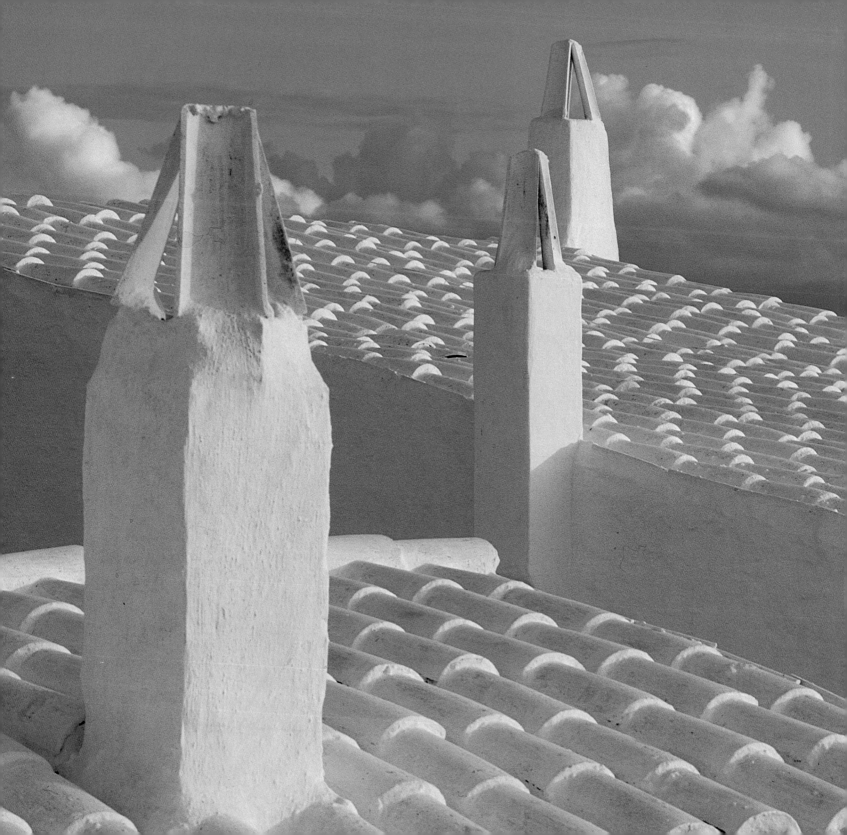

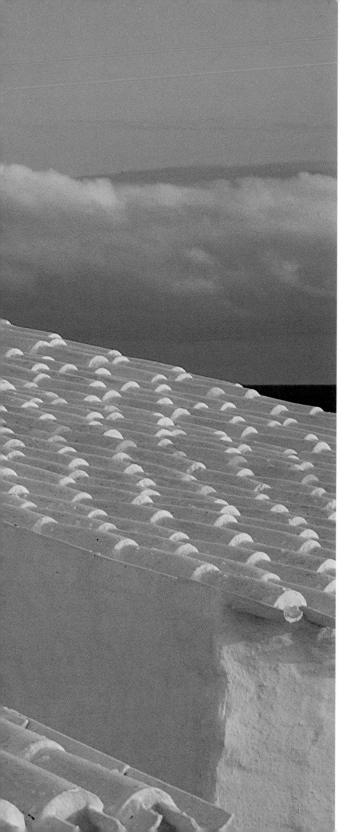

I dedicate this book to Hugh and Bret,
who share with me the experience
of these glorious islands and
whose presence adds to their beauty.

This book is also dedicated to my friend
and wonderful publisher, Nion McEvoy,
who shares my enthusiasm for these islands.

M . L .

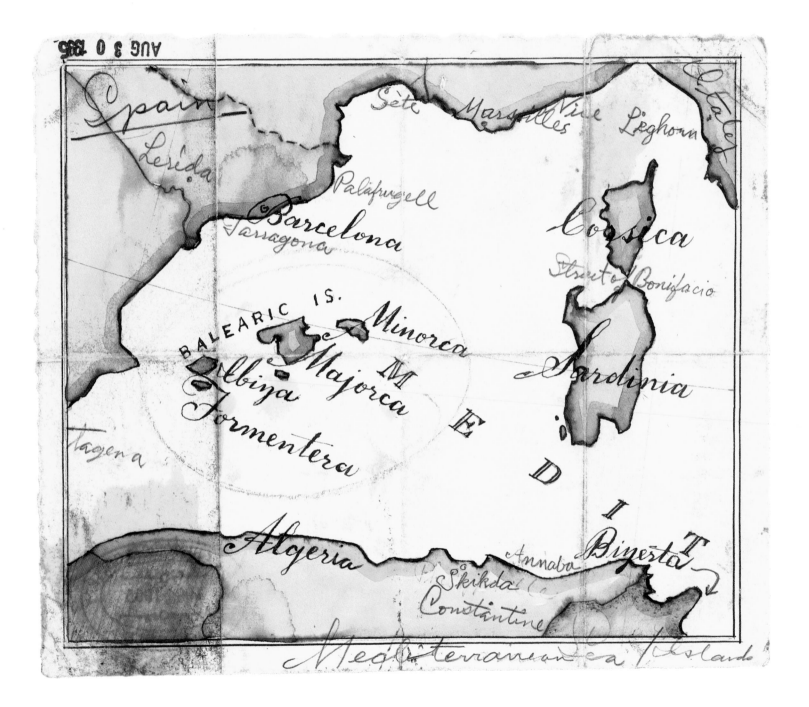

Living in the Sun

THE SPANISH MEDITERRANEAN ISLANDS

MAJORCA
MINORCA
IBIZA
FORMENTERA

PHOTOGRAPHY BY MELBA LEVICK
TEXT BY COLMAN ANDREWS

CHRONICLE BOOKS
SAN FRANCISCO

In the home of a Welsh painter, a year-round resident of Formentera, a collection
of old water jugs now serves as decoration.

preceding pages: Binibeca Vell on Minorca, with its unusual whitewashed tile
roofs, is an old fisherman's village recently converted into a resort complex.

Printed in Hong Kong.

Library of Congress Cataloging-in-Publication Data
Levick, Melba.
 Living in the sun: the Spanish Mediterranean islands:
Majorca, Minorca, Ibiza, Formentera / photography by Melba Levick;
text by Colman Andrews
 p. cm.
 Includes index.
 ISBN: 0-8118-0659-6
 1. Balearic Islands (Spain)—Pictorial works. I. Andrews,
 Colman. II. Title.
DP302.B21L48 1996
946'.75083'0222—dc20 *95--15443*
 CIP

Book and cover design by Sarah Bolles
Map illustrations by Jack Molloy
Calligraphy by Todd apJones

Distributed in Canada by Raincoast Books
8680 Cambie Street
Vancouver, B.C., V6P 6M9

10 9 8 7 6 5 4 3 2 1

Chronicle Books
275 Fifth Street
San Francisco, CA 94103

Chronicle Books ® is registered in the U.S. Trademark and Patent Office.

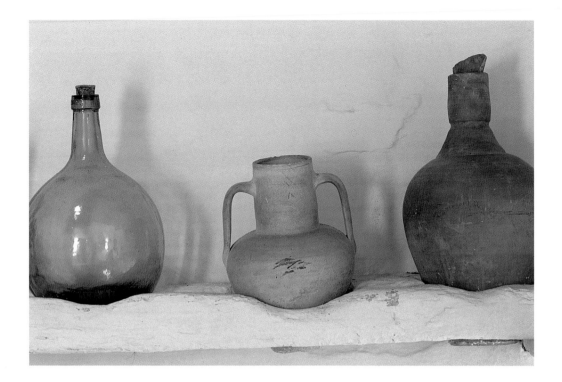

Table of Contents

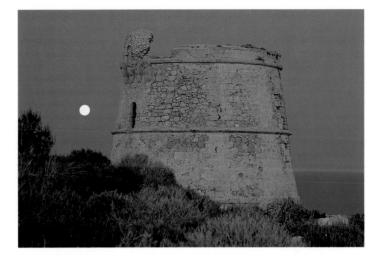

Medieval conical watchtowers, like this one on the Cap de Berberia on Formentera (for-men-TAIR-uh), are found often in the Balearic Islands. When approaching pirates or enemy fleets were spotted, the signal was given either by fire or, tradition has it, by women flashing their brightly colored petticoats.

A Note on Place Names

*P*lace names in the Balearic Islands can be confusing, because they may appear in either Castilian Spanish or Balearic Catalan form. Sometimes the two forms are nearly identical (Santa María in Castilian simply loses its stressed *i* to become Santa Maria in Balearic); other times they may seem like different names entirely (the Castilian Santa Inés becomes the Balearic Santa Agnès). As a general rule, the larger towns are known by their Castilian name and the villages, coves, and other smaller entities by their Balearic ones—though there are certainly exceptions to this rule, as well as confusing contradictions: a number of official maps of Ibiza (ib-EEZ-uh or ib-EETH-uh), for example, mark a well-known town as San Miguel, but identify the nearby cove as Port de Sant Miquel.

I have followed the style used by the Firestone Hispania Mapa Turístico de las Islas Baleares, which is more detailed than anything from Michelin or Hallweg and more consistent than the numerous locally published tourist maps of individual islands. Where the Castilian and Balearic forms are noticeably different, I have given the alternate version in parenthesis.

A further complication is introduced by the fact that accepted English usage is to render the names of Mallorca and Menorca as Majorca (my-YOR-kah) and Minorca (min-OR-kah), respectively. I have followed this convention—though this, too, introduces contradictions. Palma de Mallorca, for instance, is the capital of the island of Majorca.

↭ C . A .

The Balearic Islands are a microcosm of the Mediterranean. Their shores encircle an anthology of landscapes, both natural and societal, recalling in turn Andalusia, Catalonia, Provence, Sardinia, Sicily, the Peloponnisos, and the Maghreb. The inhabitants are a vivid mix of races and (now) nationalities, alternately staid and exhibitionistic, superstitious and free-thinking. Agriculture and tourism abut. The contemporary and the ancient coexist, with surprising grace.

The topography of the islands is virtually iconographic: dramatic limestone cliffs, sharp little mountains cloaked in scrub, hills ghostly green with olive groves, soapy-looking salt flats, silvery lagoons and cleftlike coves as narrow as fjords, beaches of both sand and stone (lapped by water colored everything from palest aquamarine to deep velvet blue), arid patches of near-desert, dense pine woods, parades of palms, and broad fertile plains scattered with almond, fig, and carob trees and crosshatched with vineyards and fields of wheat and flax—all interspersed with (and sometimes threatened by) towns that seem alternately North African, Italianate, Spanish colonial, British colonial, and international-resort in style. To know the Balearics is to know the Mediterranean at large—or at least to know its basic physical vocabulary.

Geologically, the Balearics—which are an offshore bit of Spain (its only Mediterranean islands of any size) about fifty miles from the mainland at the nearest point—are the emergent portions of two submarine plateaux, connected to mountain chains that run into the Spanish mainland. Miscellaneous islets aside (tiny Cabrera is the largest of these), there are four islands in the archipelago—Formentera, Ibiza, Minorca, and Majorca. Together, the Balearics occupy about nineteen hundred square miles of land and contain not quite seven hundred thousand permanent inhabitants—nearly half of them residing in the islands' capital, Palma de Mallorca.

The Balearics were first settled as early as 5000 B.C., probably by proto-Iberian tribes from the nearby mainland. The early residents of the islands left behind numerous souvenirs of their presence. In all, there are about five thousand prehistoric sites, monuments and otherwise, in the Balearics, the vast majority of them on Minorca and Majorca. The most memorable of these are a series of striking, sometimes eerie, stone monuments found mostly on Minorca (with a smaller number on Majorca)—conical stone towers (*tayalots*), elongated boat-shaped grave markers (*navetas* or *naus*), and

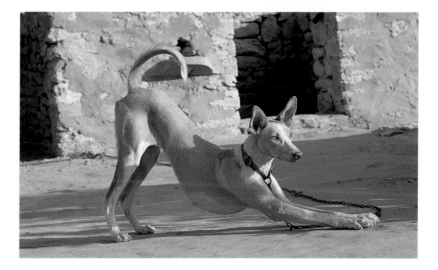

The *podenc eivissenc*, or Ibizenco hound, is a strange creature, notoriously unfriendly but a good hunter. The breed, said to have been introduced to the island by the Carthaginians, bears a striking resemblance to depictions of Anubis, the Egyptian dog charged with guarding the tombs of the pharoahs.

massive T-shaped forms, possibly altar tables (*taules*). One theory gives credit for these monuments to immigrants from Sardinia—and indeed the *tayalots* bear a resemblance to that island's mysterious *nuraghi*.

Greeks and Phoenicians came to the Balearics in their turn, and the Carthaginians showed up in the islands a couple of hundred years before the birth of Christ, establishing trade colonies and perhaps introducing the grapevine to these shores. They were followed, in succession, by the usual list of invaders—Romans, Vandals, Byzantines, Normans, and Moors. (Mercenaries from the Balearics, famous for their strength and bravery and for their prowess with the sling, fought for both Rome and Carthage during the Punic Wars. The name "Balearics" is said to derive from the word for sling in some ancient language.)

The first Moorish incursions into the islands began around A.D. 800, and the Omayyads of Córdoba definitively conquered the archipelago in 903. The Moors influenced architecture, language, and, above all, agriculture in the islands—introducing citrus and nut trees, among other crops, establishing the custom of interplanting grains and fruit trees, and building complex irrigation systems fed by waterwheels, essential to serious farming in these often water-starved islands.

The Moors were driven out of the Balearics by the powerful Catalan-Aragonese ruler Jaime (or Jaume) I, called The Conquerer, who defeated the Moorish navy in a bloody battle in the Bay of Palma on New Year's Eve, 1229 (fifty thousand souls are said to have perished). In the next few years, he retook Minorca, Ibiza, and Formentera

as well. Jaime's motives were not entirely altruistic; in conquering the Balearics, he reinforced Barcelona's hegemony in the western Mediterranean and helped secure important trade routes at the expense of the rival fleets of Genoa and Pisa.

The Balearics enjoyed a brief moment of royal glory when Jaime founded the Kingdom of Majorca in 1276 as a gift for his son, separating the islands from Aragon and uniting them with two of his other possessions, the domains of Montpellier and Perpignan on the mainland of what is now France. The kingdom lasted only sixty-seven years, through three rulers. The Balearics were then reunited with Aragon, and subsequently became part of the new Spanish kingdom of Ferdinand and Isabella.

Spain lost interest in the islands after the discovery of the Americas in the late fifteenth century; as attention turned from the Mediterranean to the Atlantic, the Balearics, left largely unprotected, were plagued by North African pirates, who alternately sacked its towns and established bases on the islands for their raiding parties. The pirates are responsible for the fact that there are almost no medieval towns along the seacoast of the islands, except for Palma and a few other fortified cities on natural, easily defended harbors. Waterside settlements would have been too vulnerable to the Barbary corsairs. The stone watchtowers that still stand on promontories and high hilltops in parts of Majorca, Ibiza, and Formentera are another legacy of this era: from these, sentinals watched for approaching ships and warned citizens accordingly.

Minorca was variously occupied by the French and English throughout the eighteenth century, but with that exception, the Balearics have remained Spanish for more than five hundred years—becoming one of Spain's seventeen autonomous regions in 1983, with the newly formed Govern Balear administering the islands from Palma.

During the Spanish Civil War, Majorca officially supported Franco—at one point, Mussolini's bombers used Palma as a base from which to attack a recalcitrant Barcelona on Franco's behalf (rumor had it that Franco planned to cede the islands to Italy in return for such assistance)—while Minorca and Ibiza remained Republican. But the people of the Balearics tend to be an independent-minded bunch, and later in the course of the Franco regime, the islands in general and Majorca in particular became known as safe havens for "dangerous" (i.e., non-Franquist) artists, writers, and the like—among them, the great painter Joan Miró and, later, the protean young Barcelona designer Javier Mariscal. To this day, the arts are well respected and frequently celebrated in the Balearics, and there are almost certainly more artists—Spanish and

otherwise—living in these hospitable climes than in any other part of Spain.

Robert Graves, who lived much of his life in Deyá, on Majorca's northwestern coast, once wrote that Majorcans, among themselves, "habitually talk Mallorquín, which is as old a language as English and purer than Catalan and Provençal, its nearest relatives." That's a nice, romantic notion, but the fact is that, thanks to Jaime the Conquerer and his descendents, what the inhabitants of the Balearics speak today (in addition to Castilian Spanish, of course) is a dialect of Catalan influenced by the dialect of the Ampurdán region on Catalonia's northern coast (whence many of Jaime's soldiers came). Officially called Balearic, the dialect is known by locals, with fierce insular pride, as Mallorquí, Menorquí, or Eivissenc, depending on the island. This linguistic heritage is partially responsible for the distinctly non-Spanish-sounding place names that lend maps of, and road signs in, the Balearics such an exotic air—Llucmayor, Capdepera, Mercadal, Talati de Dalt, Es Cubells, and so on. (One characteristic of Balearic is that it uses *"es"* and *"sa"* as definite articles in place of the *"el"* and *"la"* of both Catalan and Castilian—a usage it shares with the Ampurdán.)

Economically, the Balearic Islands survived for centuries (sometimes just barely) on agriculture, exporting almonds and hazelnuts, apricots, figs, tomatoes, cereals, wine and olive oil—and in the case of Minorca, cheese and other dairy products—to Barcelona and beyond. Agricultural products are still exported from the Balearics (Majorca's wine industry is enjoying a minor revival), and there is now some small-scale manufacturing in the islands—pottery and shoes, primarily. Ibiza also ships about fifty thousand tons of salt a year from its saltpans to the Spanish mainland. But today the most important industry in the islands, by far, is tourism.

Mass tourism—more than seven million foreigners and mainland Spaniards visit annually—has changed the islands as dramatically as did earlier invasions, altering the appearance of towns and cities (and spawning new ones), turning dirt roads into highways and quiet coves into brassy beaches, and overtaxing the supplies of water and good will.

What tourism has not done—and probably never will—is to homogenize the Balearics, to rob them of their individual personalities. These islands are not a matched set: they may belong to the same archipelago, but they are surprisingly diverse, sometimes hardly recognizable as siblings. Formentera is small, dry, mostly flat, and unselfconscious—small-scale in both its history and its hedonism. Ibiza, the mythic

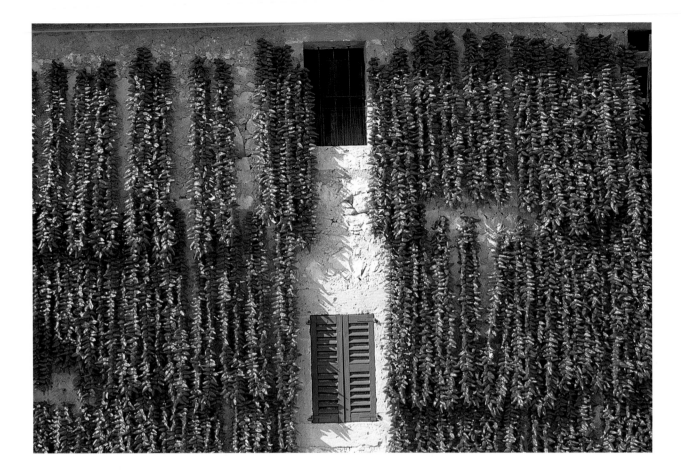

Mild red chile peppers drying in the autumn sun in the village of Portol, a few miles inland from Palma de Mallorca. In earlier times, almost every house in town was draped with strings of peppers—but, say locals, the chile oils damage the paint, so the practice is diminishing.

international not-quite-grown-up's playground, is hilly and sporadically wooded, with an exuberantly ragged coastline punctuated here and there by broad white beaches framed in tamarisk trees and pines. Majorca is almost an island nation, greatly varied topographically, with a proud and complex history and, in Palma, one of the Mediterranean's most attractive capitals. Minorca is offbeat, cross-cultural, and archaeological, an island of mist and heather, with an English accent and an almost Celtic air.

The Balearics are not, most emphatically, "Spain" in the common emblematic sense—the Spain of flamenco dancers, bullfights, huge crenellated castles, and landmark collections of Goyas and El Grecos. But they're a vivid and accessible reminder of Spain's great cultural and geographical diversity—and they're one of the brightest, most seductive corners of the Mediterranean, illuminating and animating this great sea even as they help to define it.

Majorca

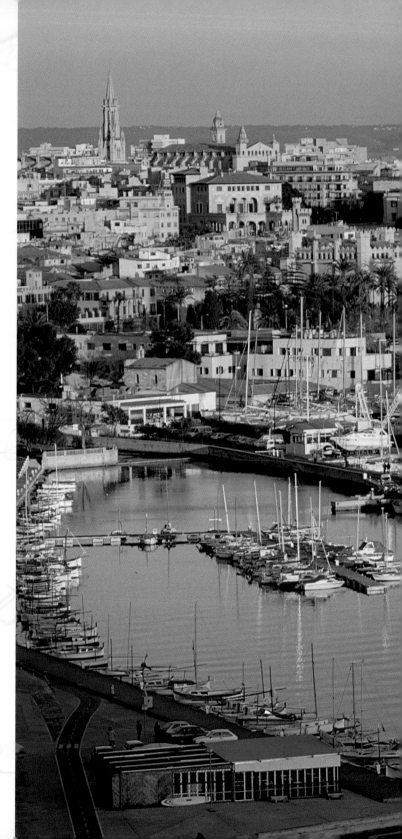

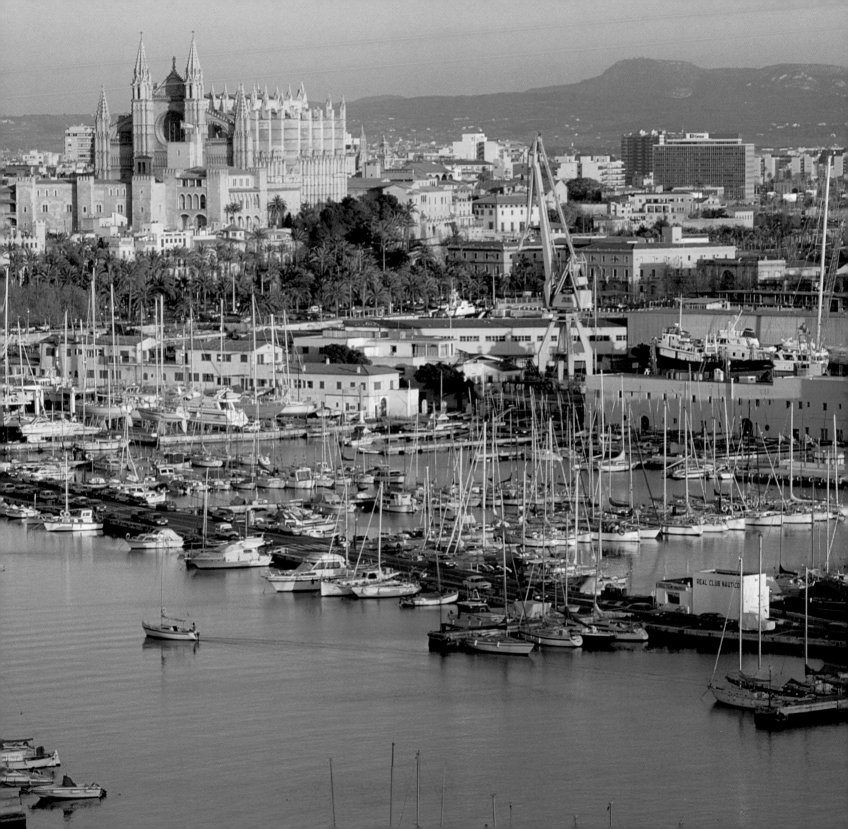

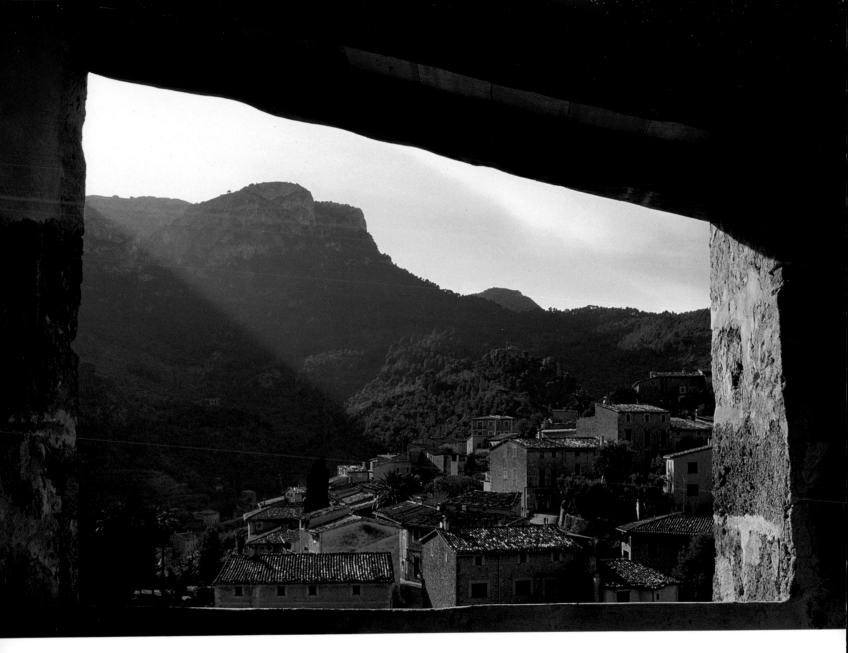

The storybook town of Deyá, where English author and poet Robert Graves lived for decades, is today a thriving artist's colony and vacation retreat. These views of the town are taken from La Residencia, which may well be the most romantic hotel on the island.

Majorca wastes no time impressing visitors: the Ronda Litoral, running from the airport outside Palma de Mallorca, curves along the ancient city walls and passes beneath Palma's magnificent Gothic cathedral, which is built of luminescent Santanyí limestone and posed grandly on a hill above the contemporary-style Parque del Mar. On the left, meanwhile, is the elegant fifteenth-century Lonja, or commercial exchange, which could pass for a Venetian palace, and beyond it is the Bay of Palma—a glittering broad harbor ringed with hills and always full of fishing boats, yachts, and passenger liners alike. A simple palm-lined seafront promenade follows the line of the bay. If you happen to arrive after dark, the vista is positively magical, with the cathedral and, on the far side of the bay, the fourteenth-century Bellver Castle both luminously flood-lit and with the bay itself alive with the twinkling, sparkling reflection of the city. But even by day, the large-scale elegance of Palma is striking.

Palma is a bustling place, said to have the most automobiles per capita of any city in Spain and the busiest airport. That airport, with direct flights to a number of European capitals, helps make the island particularly attractive to the well-to-do international set—artists, business executives, politicians, and the idle rich. Palma is also a major seaport, and the colorful, sometimes seedy Avenida Joan Miró is lined with the Scandinavian sailors' bars, low-rent topless clubs, and dimly lit pizza parlors that decorate maritime quarters the world around. Rather more dignified is medieval Palma, which might be said to begin with the cathedral and stretch inland, past La Almudaina, an old Moorish fortress turned royal palace, and into a tangle of narrow old streets that inevitably seem to lead to the attractive Plaza Mayor—in whose cafés all of Palma seems to meet. This is the liveliest part of the city, vital but discreet, and full of small surprises.

Among these surprises are a number of superb medieval mansions, many of them dating from the heady days of the thirteenth-century Kingdom of Majorca. These structures, modest-looking from the outside, are built around exquisite interior courtyards full of arches and loggias and marble columns; many are still furnished with frescoes in the Majorcan Gothic primitive style and with French and Spanish tapestries, Murano glass lamps, and other decorative riches both local and imported.

preceding pages:
Beyond the Puerto de Palma, the Majorcan capital glows in the late afternoon sun.

Outside Palma—once you get past the dreary suburbs—a remarkable expanse of countryside unfolds, unmistakably Mediterranean, lush with pines, palms, and oaks, groves of olive, almond, hazelnut, fig, carob, and assorted citrus trees, grapevines, fields of grain, thickets of bougainvillea, enormous clumps of wild irises and camellias. Handsome little farmhouses with white or earth-toned walls and flat roofs are scattered here and there, and sometimes a long tree-lined road leading to a wall of trees betrays a hidden country villa—perhaps constructed as a summer house by one of the same medieval families who built those Palma mansions.

Majorcans—even sophisticated urban ones, happy to live in Palma—remain in close touch with the rural landscape and with their island's agricultural past. A Majorcan friend once told me that, when his father bought a piece of land on the edge of Palma to build a house, the first thing he did was to plant tomatoes—before breaking ground for the structure itself. When the house was finished, he reasoned, he'd need tomatoes in the kitchen. "This is just how we think," added my friend.

Majorca, which covers just over fourteen hundred square miles and measures about sixty-two miles across at its broadest point, is shaped rather like a chunky square with rounded corners and two bashed-in sides. Roads across the length of the island are usually more or less straight and gently undulating. Toward Majorca's northwestern flank, though, real mountains rise up from the planted plains, in places reaching heights of nearly five thousand feet. The winding, jagging roads that run along their coastal crests offer stunning views of the Mediterranean—if you dare take your eyes off the road for even an instant.

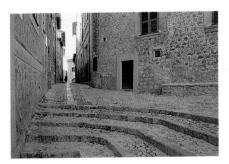

Fornalutx is built from, and paved with, stones from the surrounding mountains.

On the breathtaking Cabo de Formentor, on the far northern tip of the island, raw, primeval rocks jut up out of the water like the prows of sinking ships, and the sea seems perpetually stormy; gulls hang motionless overhead, frozen in place by the wind. On Majorca's southeastern coast, huge caves gape in the limestone palisades, cavernous and ornately decorated by relentless nature. They are the island's other cathedrals.

The urban landscape of the island is similarly diverse: perched high above both sea and valley in the northwest are the celebrated hill towns of Deyá—longtime home of Robert Graves as well as an artists' colony and vacation retreat particularly popular with the Dutch and Germans—and Valldemosa, where the Austrian archduke Ludwig Salvator lived much of his life, and in whose frescoed seventeenth- and eighteenth-

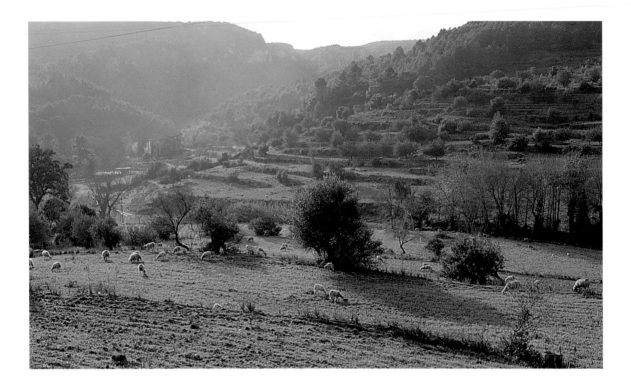

Sheep graze on a verdant hillside off the coastal road near Valldemosa.

century Carthusian monastery George Sand and Frédéric Chopin spent one famous winter. (Winters here are tranquil and, in some parts of the island, quite mild.)

Further along, on flat land a few miles to the northeast, is the sunny, French-flavored town of Sóller, whose quiet streets are lined with green-shuttered fieldstone buildings, most of them with orange trees in the backyard. The French accent is genuine: agricultural products from the region were historically traded not with Palma but with Marseille, through the picturesque Puerto de Sóller, nearby—and some local families now have a Marseille branch, and vice versa.

The towns of the interior, many of them built of red stone, seem snug and sleepy—from the wine towns of Binisalem and Inca to the villages of Portol (famous for its ceramics) and Petra (birthplace of the eighteenth-century Franciscan monk Fra Junípero Serra, who founded the first missions in California). The beachfront resort communities of Puerto de Pollença, Cala Ratjada, and Puerto de Alcudia, among others, stubbornly retain traces of antique charm amidst the touristic clutter.

Majorca is a large little island, solid and self-confident, generous with its beauty and almost offhandedly diverse. Majorca has breadth, and it demands a wide view.

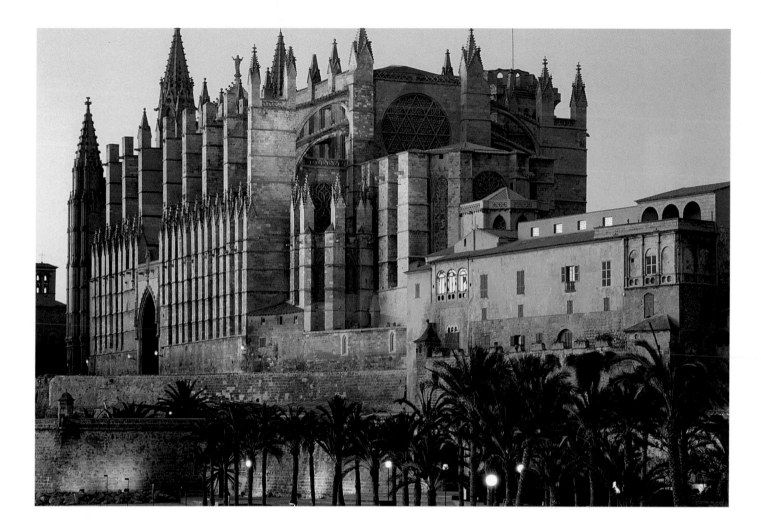

Palma's magnificent cathedral, built of luminescent
Santanyí limestone between 1230 and 1601, is one
of the largest such Gothic structures in Europe. The
main altar is surmounted by an ornate wrought-iron
baldachin designed by a young Antoni Gaudí.

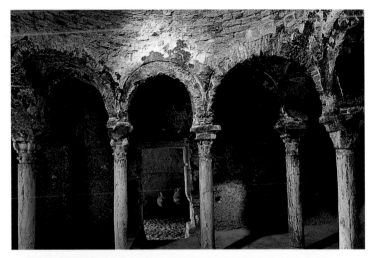

This 10th-century Moorish bath is the only structure that remains, unrestored and more-or-less intact, from the Muslim occupation of Palma, which lasted from the ninth through the early thirteenth century.

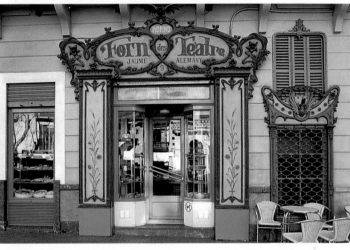

The Forn del Teatro is one of the most popular of Palma's bakeries, as much for its façade as for its pastries.

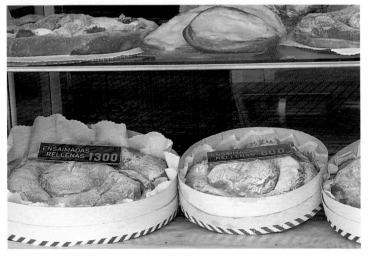

Ensaimadas—large, airy pastries coiled like a snail's shell and dusted with powdered sugar—are Majorca's most celebrated confection, famous throughout Spain. Traditionally made with lard shortening (*saïm* in Mallorquí), they are sometimes filled, like these, with custard or candied squash.

Palma's old quarter is webbed
with narrow, curving streets.

The thousand-year-old Casa Vivot
in Palma, one of the most ancient
houses in the capital, is opened to
the public several times a year.
The library is full of treasures.

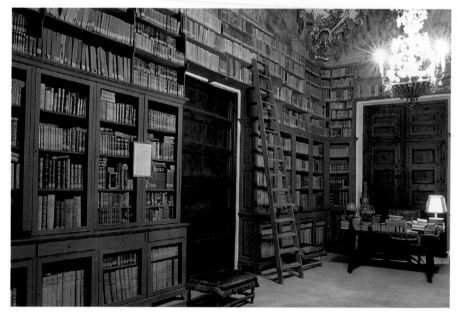

Casa Moragues, yet another lovely old house
in Palma, is finished with exquisite details,
like these brass locks and handles.

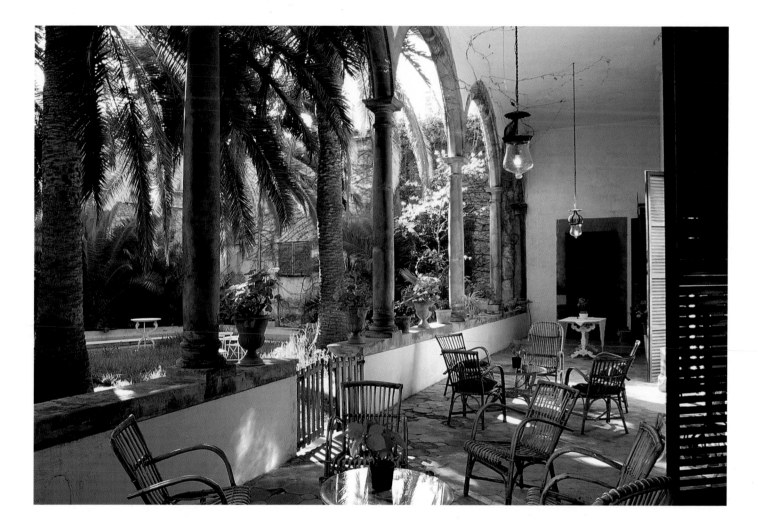

In the summer months, Majorcan terraces, like
this one running along the side of the Casa
Vivot, function as extended living rooms.

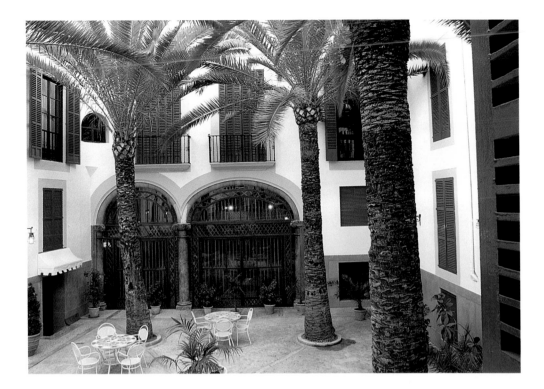

The attractively old-fashioned Hotel Born in Palma, recently refurbished, was once a monastery.

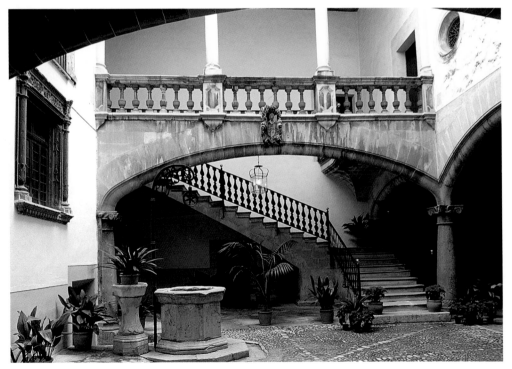

Palma is renowned for its beautiful patios and interior courts. This one, at the Casa Oleza, another of the capital's venerable old private houses, is visible from the street: It is considered such an architectural gem that the city requires it to remain accessible to public view.

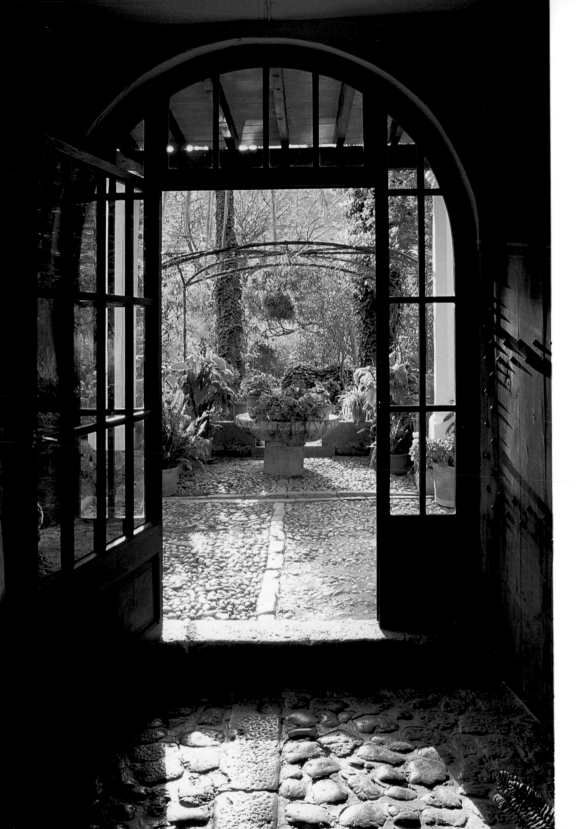

Fieldstone paving extends from inside
to out at the villa called Son Marroig,
where the Austrian archduke Ludwig
Salvator (1847–1915) lived. Ludwig
took a great interest in local archaeol-
ogy, history, and flora and fauna, and
the villa is open today as a museum,
showcasing his collections.

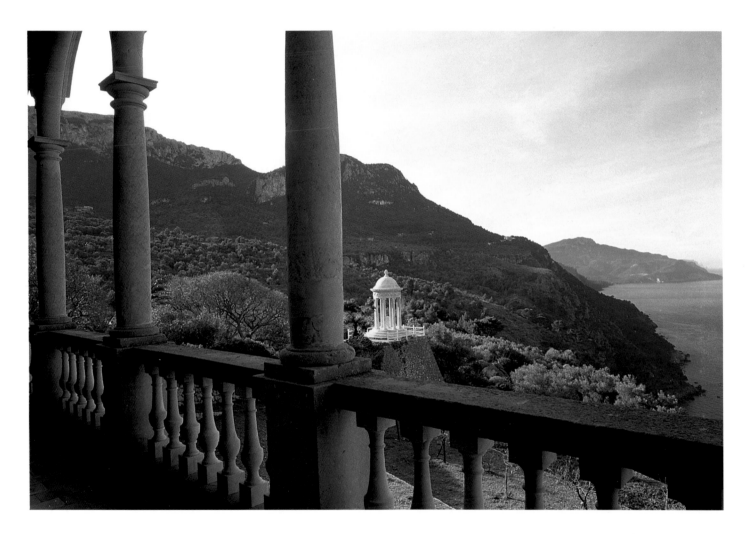

From Son Marroig, the view of the Majorcan coastline and the Mediterranean is panoramic. Ludwig Salvator is said to have contemplated nature from the domed pergola overlooking the sea.

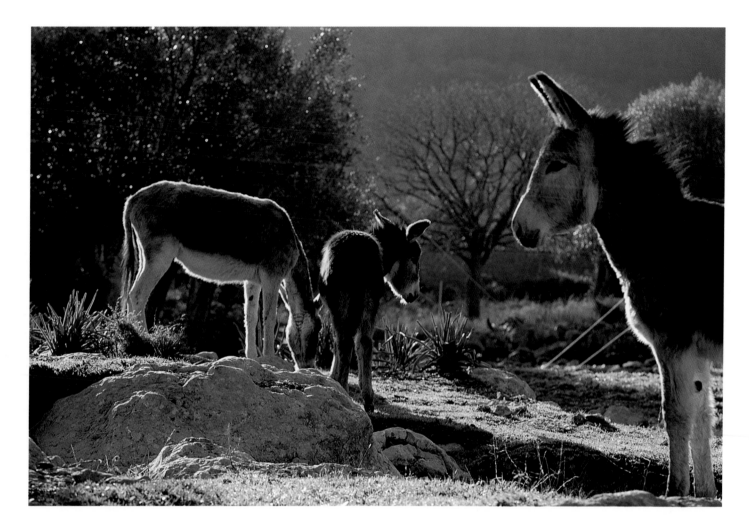

Donkeys browse by the road between Valldemosa and the
coast. Until recent years, these beasts were the principal
means of transportation for Majorcan farmers and were the
engines for both ploughs and threshing wheels.

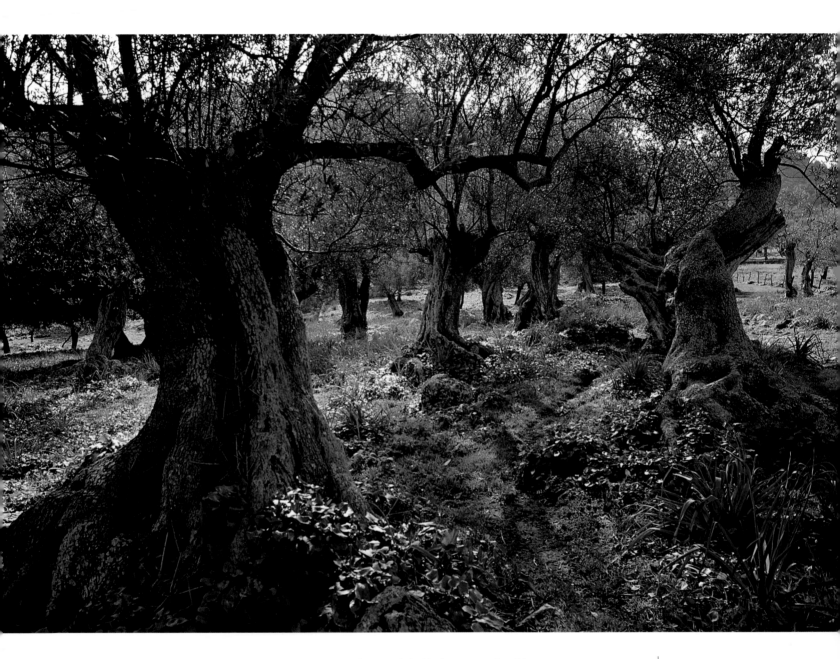

These gnarled old olive trees at Son Oleza, a private estate near
Valldemosa, might be as much as several hundred years old.

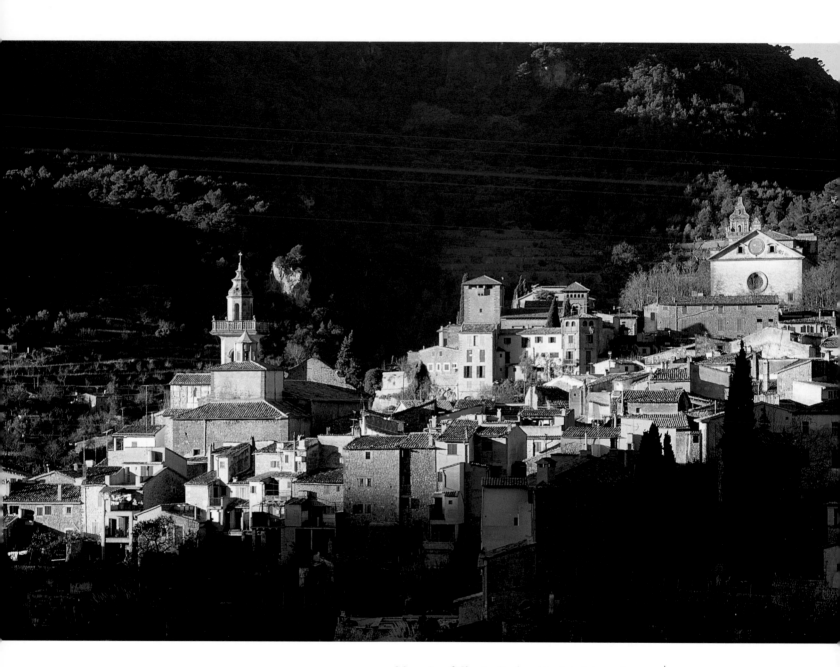

Memories of Chopin, Sand, and Ludwig Salvator have
made Valldemosa a popular tourist destination.

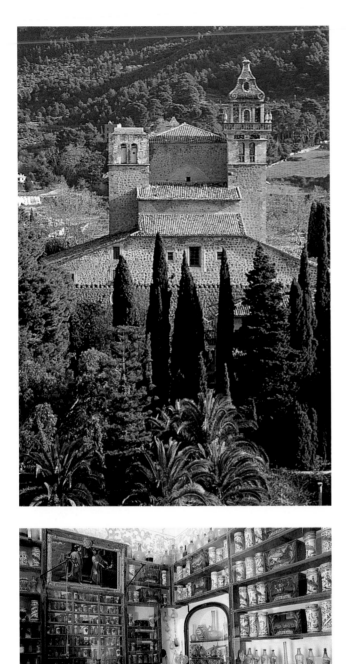

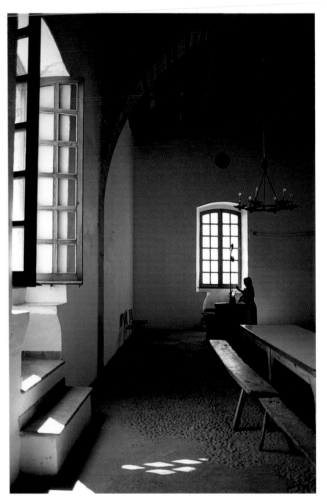

above left: Frédéric Chopin and George Sand spent the winter of 1838–39—not particularly happily—at this seventeenth- and eighteenth-century Cartuja or Carthusian monastery at Valldemosa.

above right: At another of Majorca's many monasteries, a nun draws water from a cistern.

This antique pharmacy at the Cartuja dates from the seventeenth century and was in use until the late 1800s.

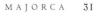

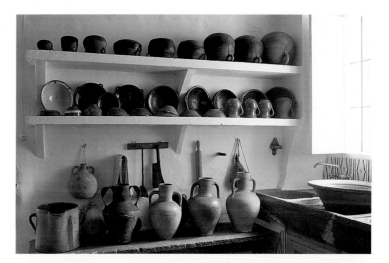

Traditional ceramic kitchen pots and bowls are still used daily at Sa Torre, a historic *finca*, or rural estate, in the hamlet of Ses Alqueries.

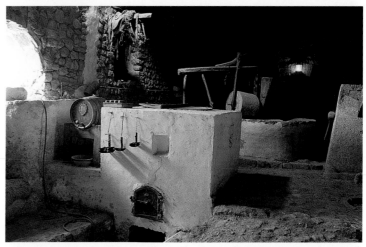

The old-style olive press in this private home near Deyá is no longer functioning, but the same time-proven technology is still used to produce oil elsewhere in the region.

Food is served in the wine cellar at Sa Torre, which now accepts guests for meals and short stays as a part of Spain's *Agroturísmo* program.

The *finca* of La Granja, an important example of medieval Majorcan architecture, is today a museum devoted to traditional arts and crafts. Located near Esporles, northwest of Palma, La Granja is also famous for its gardens and fountains—and it sells its own marmalades, cheese, herb liqueur, and other products.

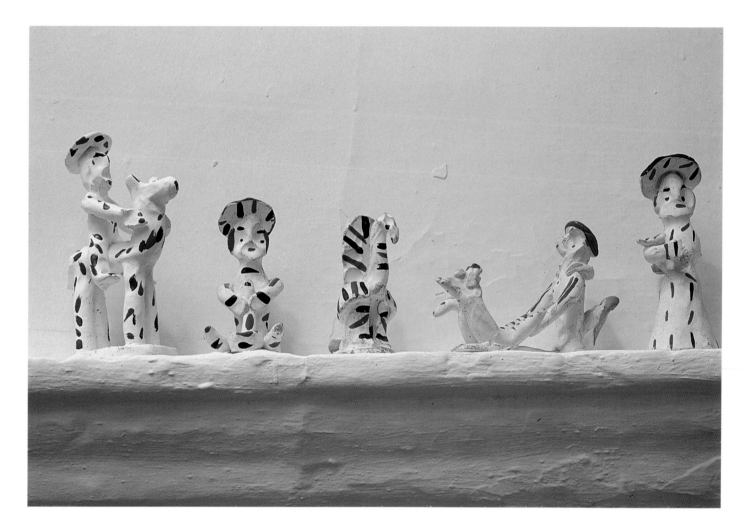

Portol, a few miles inland from Palma, is famous for these traditional clay figures, always decorated with red and green. They are called *siruells*, Mallorquí for "whistles"—which is just what they are.

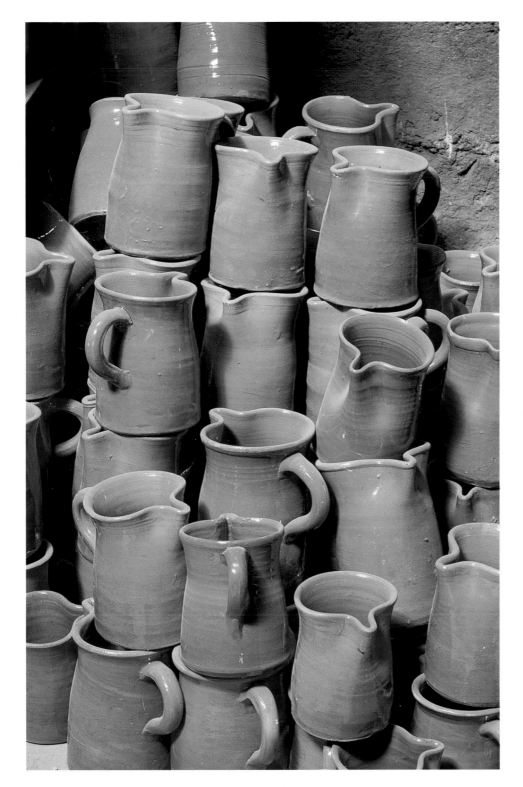

Portol is also well known for its pottery. Simple handmade ceramic pitchers like these, seen in a local workshop, are sold all over Majorca.

This handsomely restored old *finca* in Ses Alqueries serves as a home and studio for an English painter and his wife.

At Son Oleza, in the mountains above
Majorca's northwestern shore, a house
is built around a stone-paved patio.

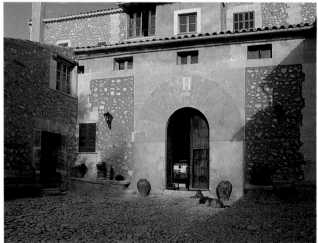

Sa Torre is an elegant country
house, but the name of its village, Ses
Alqueries, means "the Farmhouses."
Ses Alqueries is not far from Binisalem,
the island's most prominent wine town.

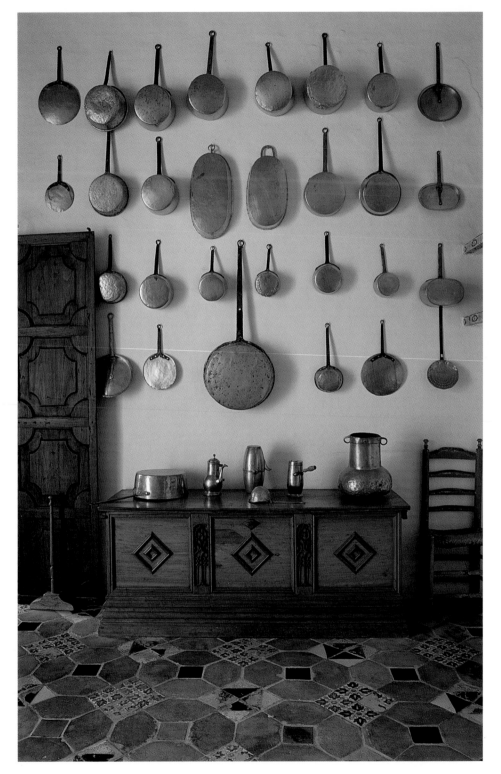

A collection of copper pots and pans covers a wall in the kitchen in this Majorcan *finca*.

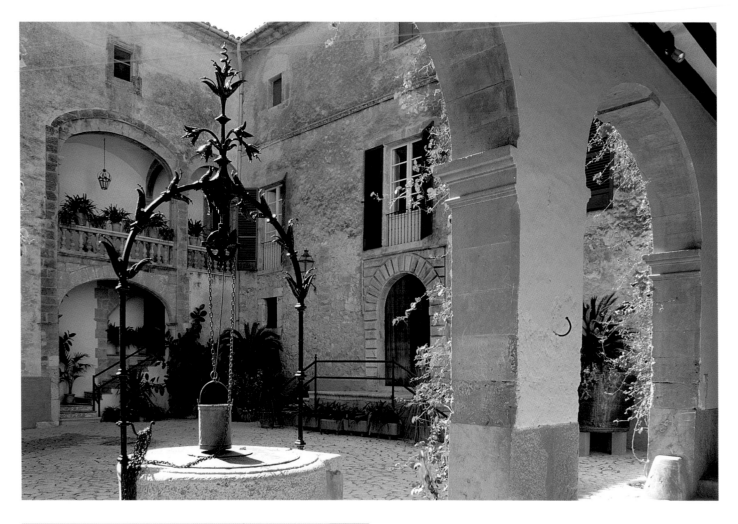

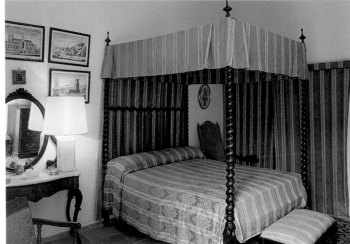

above: Majorcan *fincas* were built to be self-sufficient, and they almost always include a well or cistern—usually in the central court or patio, as at this house in the village of Sarriá, between Palma and the northwestern coast.

The elegant bedroom at this *finca* in Sarriá is typically Majorcan in style. Spiral columns inspired by the Italian Baroque, like those on the four-poster bed, are a common feature of Majorcan furniture.

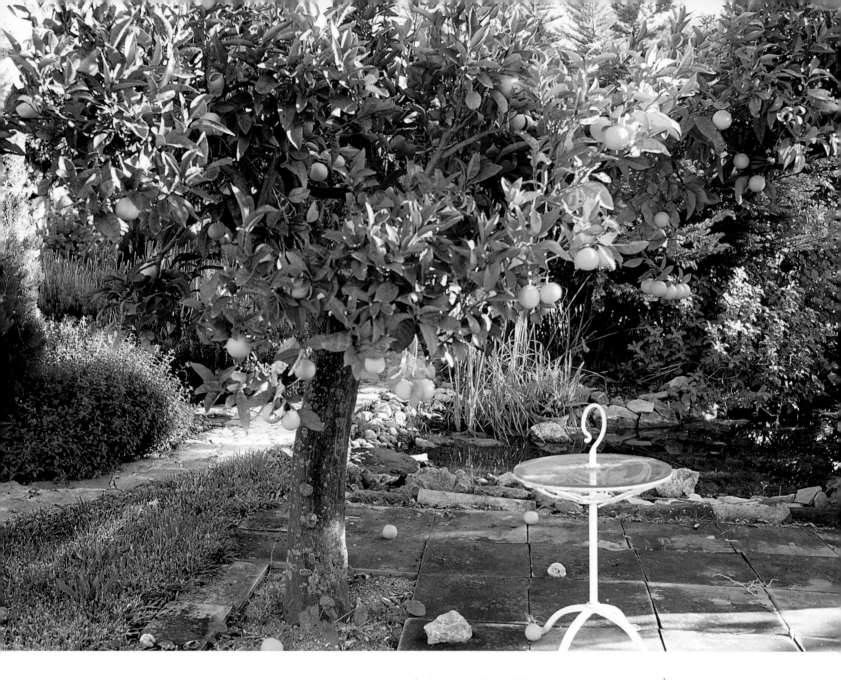

In a garden of a house near Puerto Sóller, owned by an English
woman, stand orange trees, emblematic of the region.

From another part of the garden, the Bay of Sóller can be seen shining in the distance.

On one side of the house, a medlar tree yields slow-ripening yellow-orange fruit all summer long.

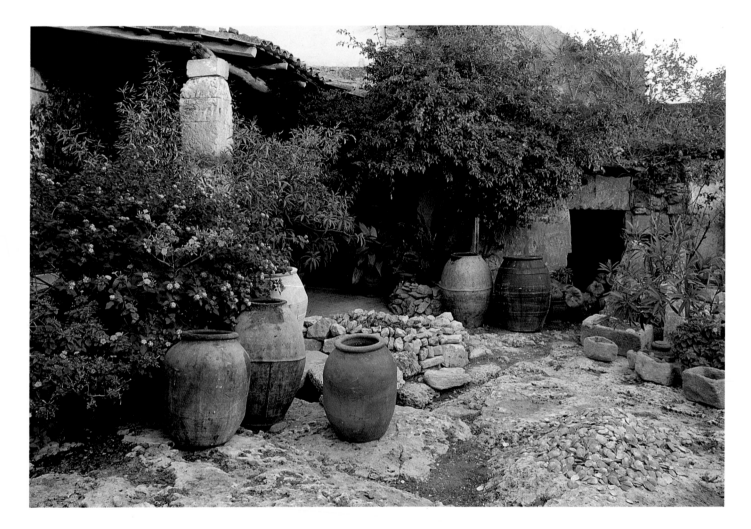

A private residence in Santanyí—a medieval town southeast of Palma,
famous in earlier times for its stone quarries—houses a collection of
ceramic vessels and wooden doors from all over Spain.

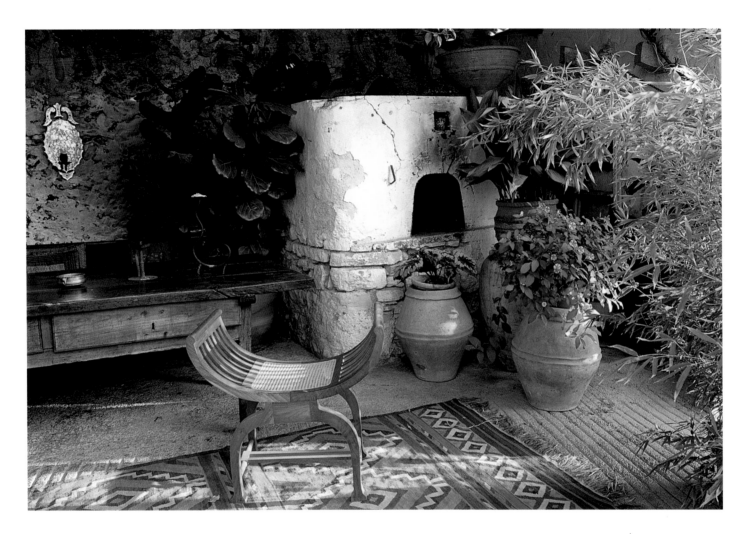

The covered exterior "living room" of a private house in Santanyí
blends indoors and outdoors.

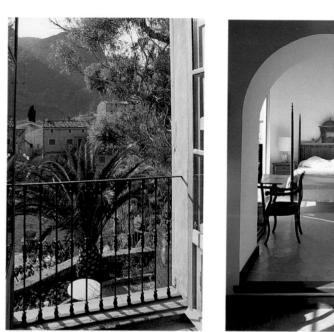

A view from the romantic La Residencia Hotel in Deyá.

far right: Bedrooms at La Residencia are furnished with Majorcan antiques.

Majorcan fishermen set off every day from coves all over the island—like this one near Cabo de Formentor.

An umbrella shades a
private garden terrace
near Cabo de Formentor.

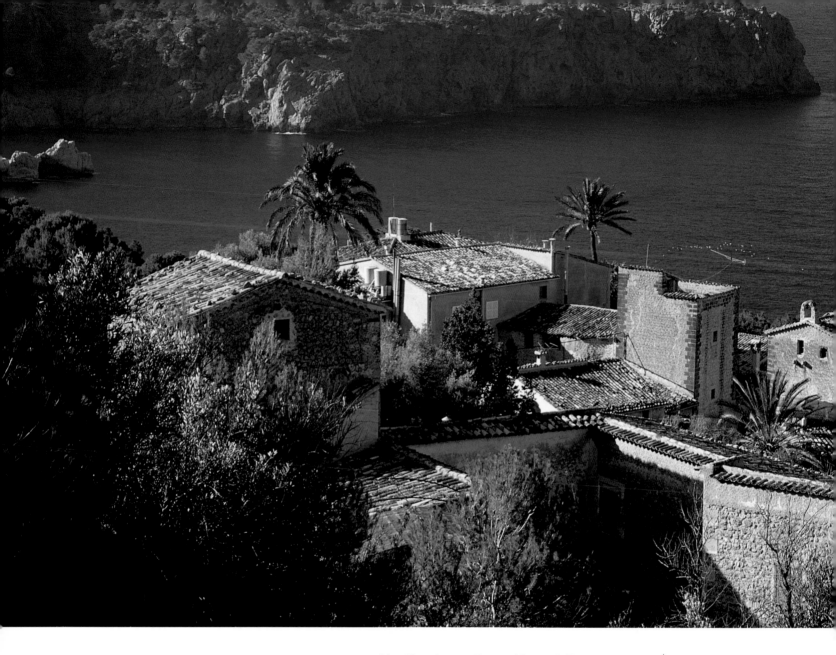

Lluc-Alcarí, between Deyá and Puerto Sóller, is set in one
of the most beautiful *calas,* or small coves, on the island.

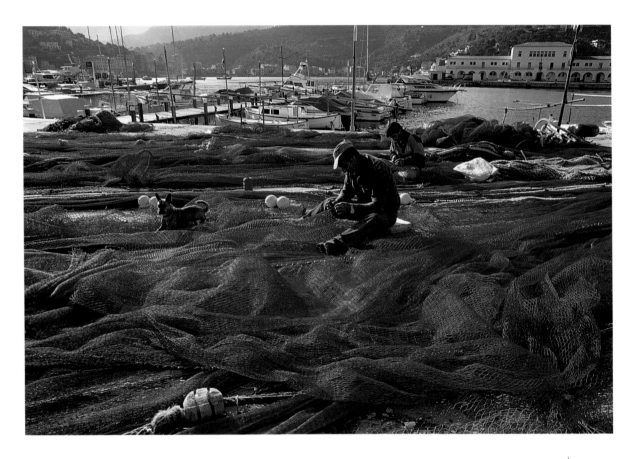

Fishermen dry their nets at Puerto Sóller, the best
natural harbor on Majorca's rocky northwestern coast.

MINORCA

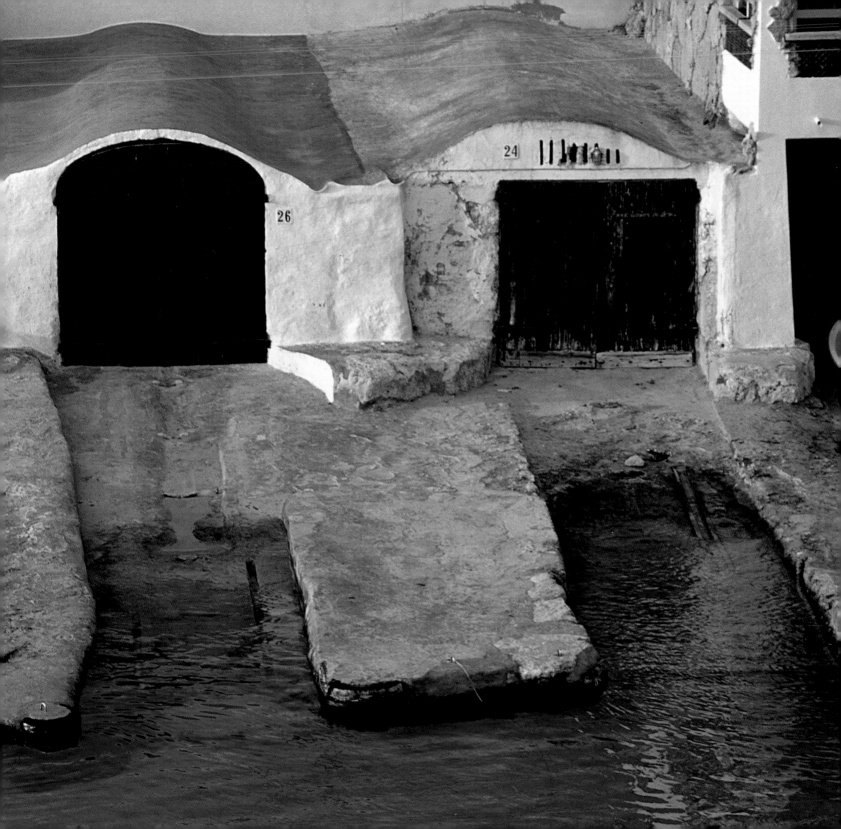

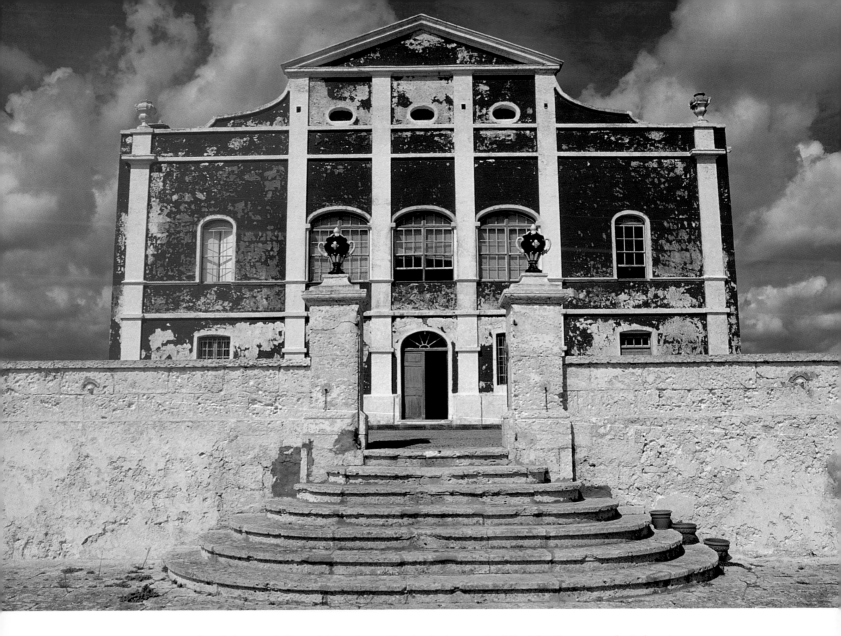

The villa called Formet Vell, near Mahón, is considered a classic example of English-Minorcan neoclassical architecture. The typical rust color of such houses is a nautical hue, apparently first applied to houses simply because the British didn't like whitewash or because this was the only color of paint available in any quantity. Though some rust-red houses on the island are frequently repainted to retain their pure color, others are allowed to peel and weather like this one—since repainting is very expensive.

The people of Minorca tell a story on themselves: After God had finished creating the island of Majorca, it seems, St. Peter came to him and begged to be allowed to make an island of his own. God granted him permission, and St. Peter proceeded to create Minorca. Seeing that Peter, frankly, hadn't done a very good job, God said, "All right, Peter, I'll tell you what: Now you take care of the Majorcans and I'll take care of the Minorcans." In other words, their island, shaped like a slightly lumpy kidney bean, may lack the beauty of its neighbor, but Minorcans consider that they live a better life. Perhaps this is why they are famous for their easy-going ways and sense of humor.

Minorca, the northernmost and second-largest of the Balearics, is geologically distinct from the rest of the archipelago, and may have been part of the now-submerged massif that once united Sardinia and Catalonia. The island's northern coast, exposed in fall and winter to strong north winds, is deeply and unevenly serrated; the southern coast is lined with high, flat bluffs. The soil on Minorca varies greatly in quality, being generally fertile in the highlands and valleys, but chalky and unyielding on the plains. The cultivated portions of the land are broken up into small fields enclosed by low fieldstone walls, like veins pushed up through the skin of the land. This gives parts of the island an almost claustrophobic feeling. Much of the uncultivated land is covered with prickly flora—cactuses, aloe plants, and heather.

Minorca stands apart from the rest of the Balearics historically as well. From 1713 to 1756, 1763 to 1782, and again from 1788 to 1802, the island was under British rule. Admiral Nelson visited Minorca, and may have lived here briefly with Lady Hamilton—and a lesser British naval hero, George Farragut, the father of the great nineteenth-century American naval hero David Farragut, was born in the Minorcan town of Ciudadela while the island was a British possession.

preceding pages:
The Cala Alcaufar, one of the many coves, large and small, that ring Minorca, has long been a haven for fishermen (whose boathouses are sometimes built into the rock below their houses, rather like garages), but is now becoming a popular *urbanización*, or development, for tourists.

below: The streets of Ciudadela, with their decorative façades in pastels and earth tones, seem more Italian than Spanish in spirit.

bottom: English-style hardware and lace on this door in Ciudadela suggest London more than a town in the Mediterranean.

Distinct traces of the occupation, however long ago and relatively brief, color the island vividly to this day: Minorca is the only place in Spain where houses are routinely built with sash windows but without balconies. Queen Anne and Chippendale antiques may still be found in many homes, as may rocking chairs—otherwise all but unknown in continental Europe. The style of typical Minorcan houses of the English period is unique: the architecture is Palladian, with rigorously pure classical motifs, but the buildings are painted a deep rust color with white trim. This hue derives from the paint used as a sealer below the waterline on British ships—or, according to some sources, used to paint the decks so that sailors wouldn't notice their spilt blood during battle. There is nothing remotely like these houses anywhere else in Spain.

English words pepper the Minorcan dialect, too. In Catalonia and elsewhere in the Balearics, for instance, the word for "bottle" is *ampolla;* here it is *botel.* A colloquial phrase for "a few people" is *una jane i un boy.* There are also, it might be noted, a good many blue-eyed Minorcans running around.

The British also changed the very look of the land, by introducing dairy farming on a large scale. Cows now graze the countryside in place of goats and sheep, and farmlands are planted mostly with fodder crops instead of the common Mediterranean trinity of wheat, grapevines, and olive trees. Even fruit and nut trees are in relatively short supply. As agricultural consolation, though, the island is famous today for its milk, cheese, and ice cream. Minorca's other important industry, besides agriculture, used to be shoe manufacturing, and it is said that in the nineteenth century almost half the population was involved in this occupation. Shoes are still made here, but on a much smaller scale.

It may also be due to the British that Minorcans are so fanatical about horses. They raise them, train them, race them—and incorporate them into their fiestas as well as their daily lives. And when they're not on horses, Minorcans are likely to be in boats. Though all the Balearics have extensive coastlines indented with coves both large and small, Minorcans seem particularly oriented toward the sea. In the summertime, some leave their island homes, move onto their boats, and spend months moving slowly from one cove to another.

The capital of Minorca is Puerto Mahón, or simply Mahón (Maó in Balearic), built around an excellent natural harbor now walled in on one side by tall houses built

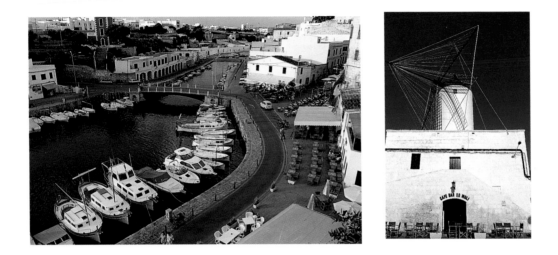

Ciudadela (Ciutadella), Minorca's oldest and second-largest city, has a graceful, canal-like port. Cafés and restaurants along the quay lend the waterfront an animated air.

above right: The old Ciudadela windmill, its sails now tethered, has been turned into a popular bar and café. The interior workings of the mill are now beautifully displayed in a small museum next door.

into the rock. (An old sailors' rhyme goes, "Junio, julio, agosto y Puerto Mahón / Los mejores puertos del Mediterraneo son"—"June, July, August, and Port Mahón are the best ports in the Mediterranean.") The city's Irish-sounding name in fact seems to derive from the name of its Carthaginian founder, Mago or Magon.

Ciudadela, Minorca's second city, on the island's western end, boasts a particularly beautiful fortified harbor, which is long and narrow and curves sinuously inland like a Venetian canal. Said to have been founded by the Phoenicians, and long occupied by the Moors, Ciudadela was the island's original capital and remains its religious seat. It is a prettier town than the rather plain Mahón. Its Plaza del Born and Carrer de Ses Voltes, in the urban center, are lined with whitewashed porticoes, lending them an ordered, almost noble look, more Italian than Spanish. Winding alleyways branch off from them, passing medieval houses with decorative façades, often in pastel hues.

Many of Minorca's archaeological monuments—*talayots*, *taules*, and other remains—are to be found along the road between Mahón and Ciudadela (a highway built in the eighteenth century by Sir Richard Kane, a well-liked British military governor of the island). Signs point out these sites, which are always open. Worn by time and weather, erected by—and sacred to—a long-vanished people, they are a dramatic counterpoint to British Minorca, as foreign to our time as rocking chairs and ice cream are familiar.

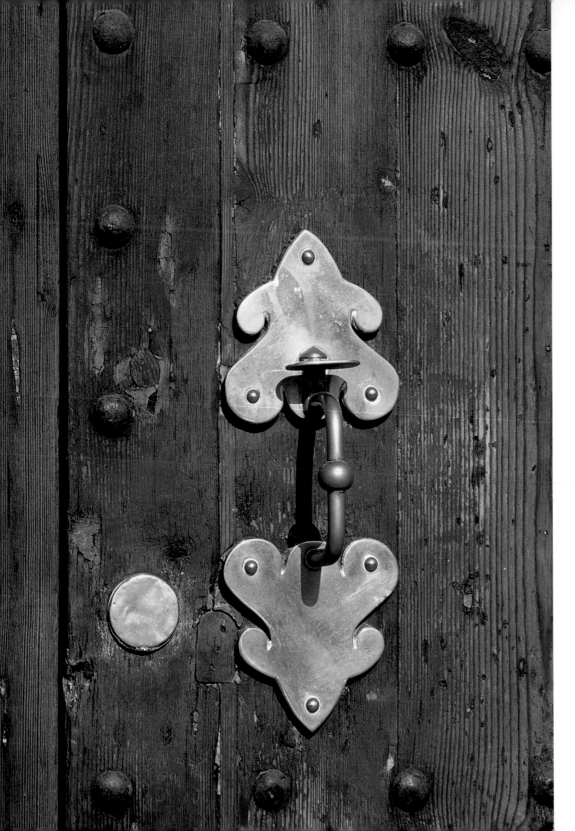

This door handle in Ciudadela is one
of the island's many English accents.

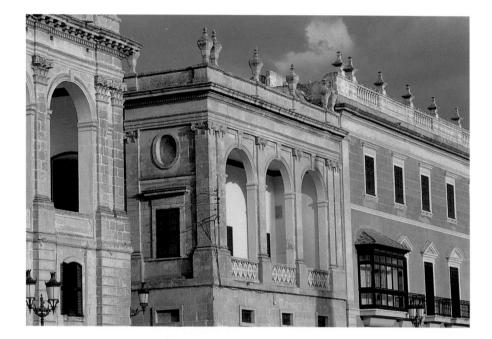

The large tree-lined Plaça del Born, once a Moorish parade ground, is the site of several imposing nineteenth-century neoclassical palaces.

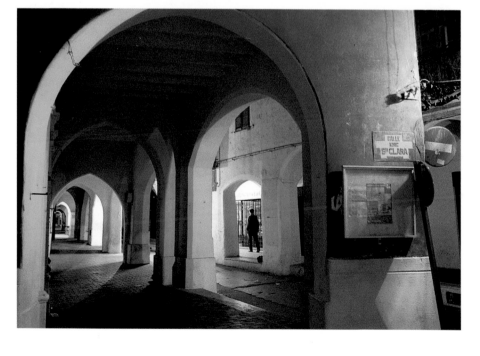

The beautiful arcades of Ses Voltes, "The Arches," in the center of Ciudadela, date from Moorish times.

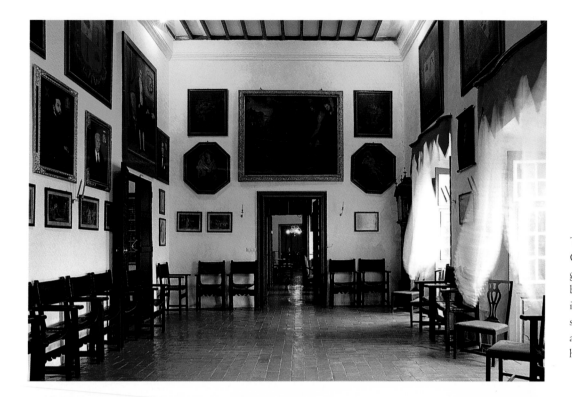

The Palacio Barón de Lluriach in Ciudadela, the oldest of the city's great houses (as the Lluriach baroncy is the island's oldest title), is decorated in haute-Minorcan style. The salon is furnished almost exactly as it was when the house was built in 1608.

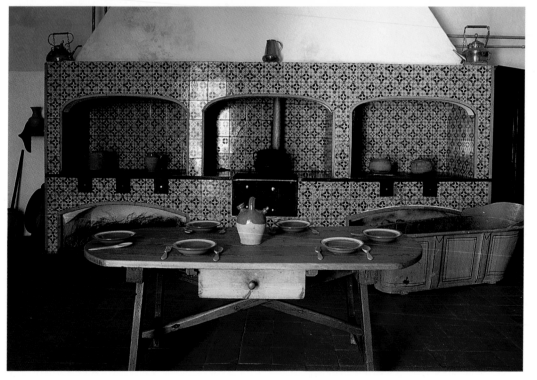

Several rooms in Ciudadela's Palacio Salort, including this superb Minorcan kitchen, are open to the public.

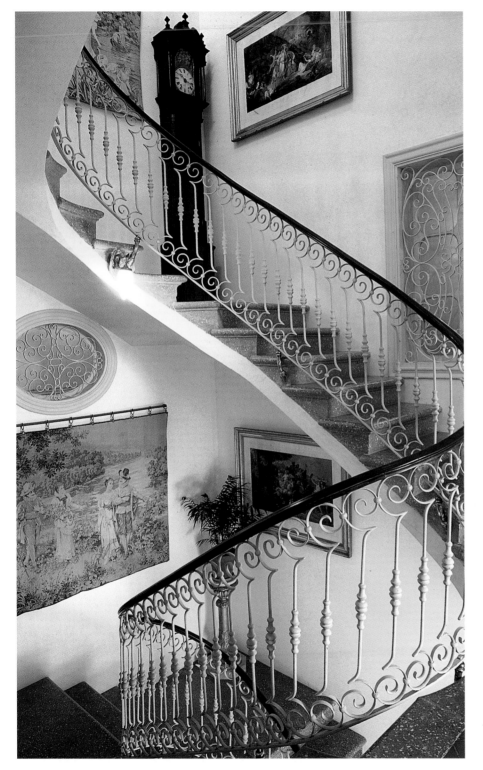

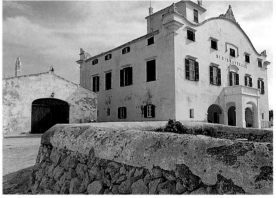

The owner of Binisafúller, a house near San Luís, is Minorcan, but the exterior echoes the Catalan Baroque style and the interior decor (left) is strictly English.

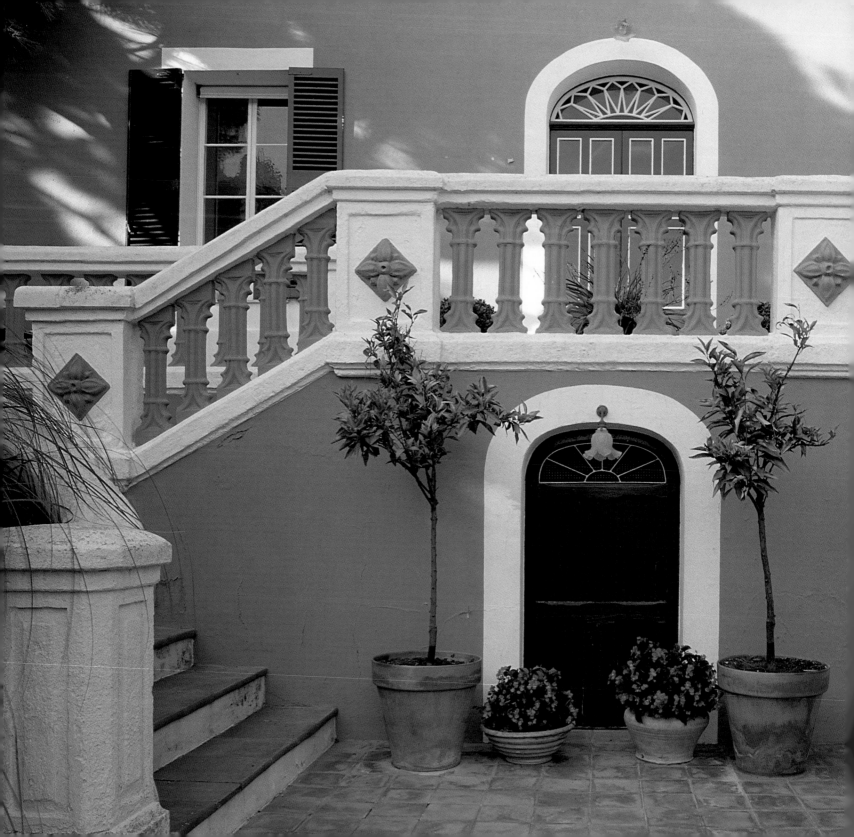

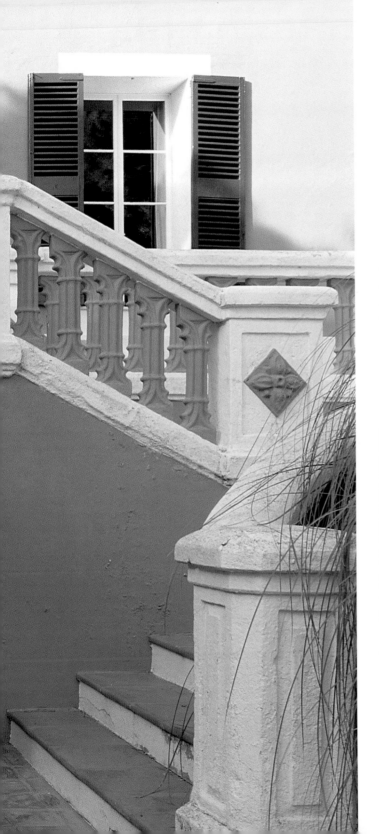

One of the most attractive and sophisticated private houses on Minorca, Sa Marjal—near the beautiful *cala* of Turqueta, southeast of Ciudadela—was originally a summer house for the owners of one of the *palacios* of Ciudadela. Today, the property of a Minorcan architect and his family, the house is unmistakably Mediterranean in many ways, but English-style refinements are everywhere.

below: Bougainvillea brightens the entrance hall.

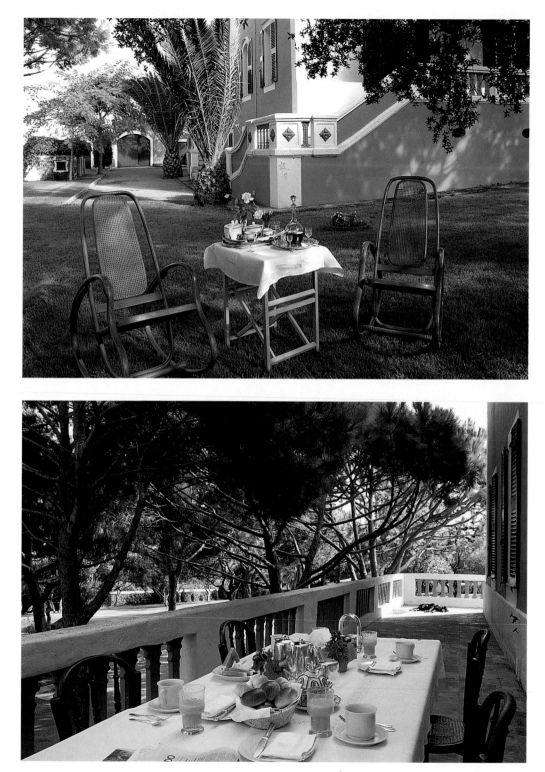

Apéritifs are served on the lawn in the late afternoon at Sa Marjal.

For at least half the year, breakfast is served on the terrace.

Minorca's famous Mahón cheese, eaten all over Spain and granted a *denominación de origen*, or guarantee of origin, by the Spanish government, is made in both industrialized and farmhouse versions. These are the latter, produced from unpasteurized cow's milk at a *finca*; each *finca* typically makes fifteen or twenty such cheeses a year for personal use.

An Italian couple extensively landscaped their house near the
Mahón airport, adding a typical Minorcan gate to the garden.

Bougainvillea, whitewashed walls, green
shutters, and red patio tiles add up to a
portrait of a typical Minorcan house.

In preparation for a party,
the couple has collected
an assortment of breads in
many styles, all made on
the island.

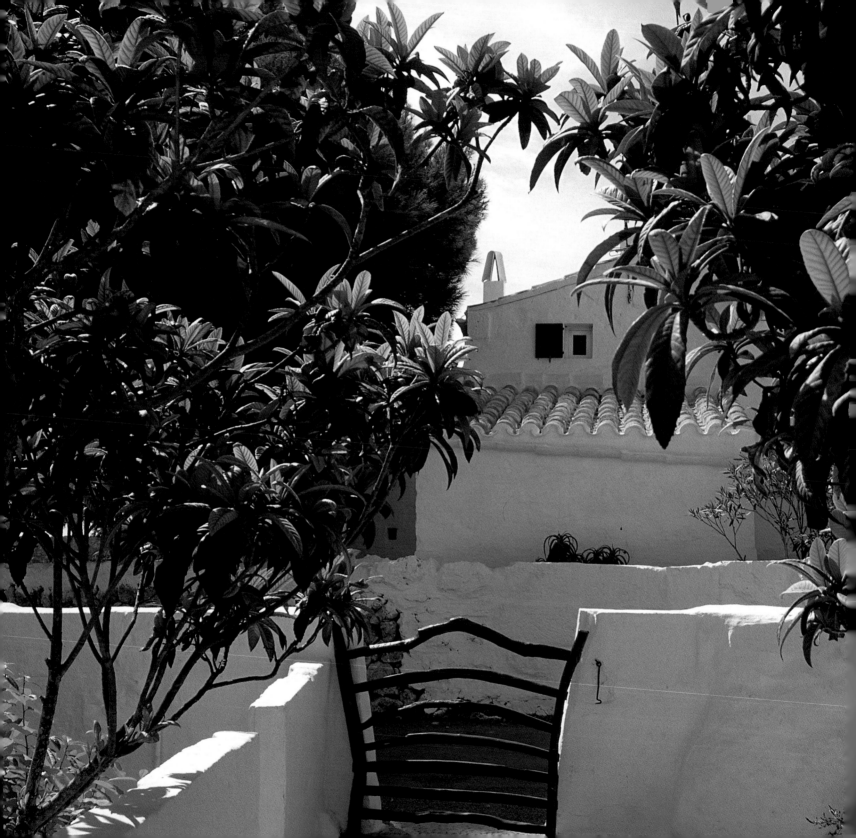

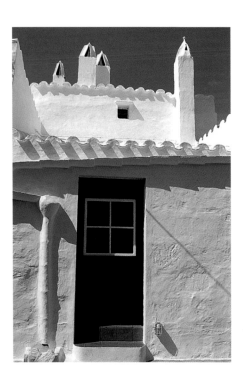

The tall, slender Minorcan chimneys are typical of this part of the island.

Pomegranates, seen here growing next to a cistern in San Luís, are a part of the traditional Balearic diet.

far left: San Luís (Sant Lluís), Minorca's famous "white village" just south of Mahón, was the seat of the island's French government in the mid-eighteenth century, but it's now popular with British retirees.

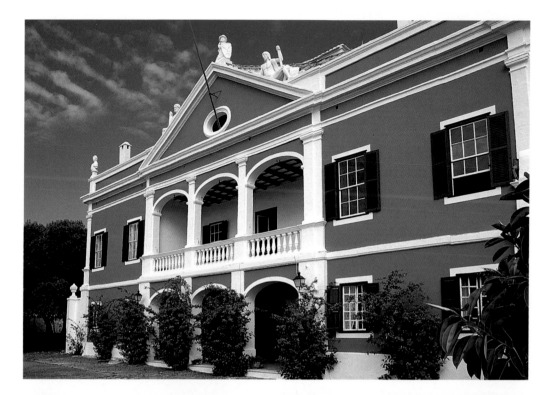

Perhaps the most famous house on the island is San Antonio, popularly known as the "Golden Farm." It was supposedly inhabited for a time, in 1799, by Lord Nelson and his lover, Lady Hamilton. The Golden Farm's color, of course, is not gold but the deep rust hue typical of English-built houses on the island.

A window at the Golden Farm could almost belong to an English country house.

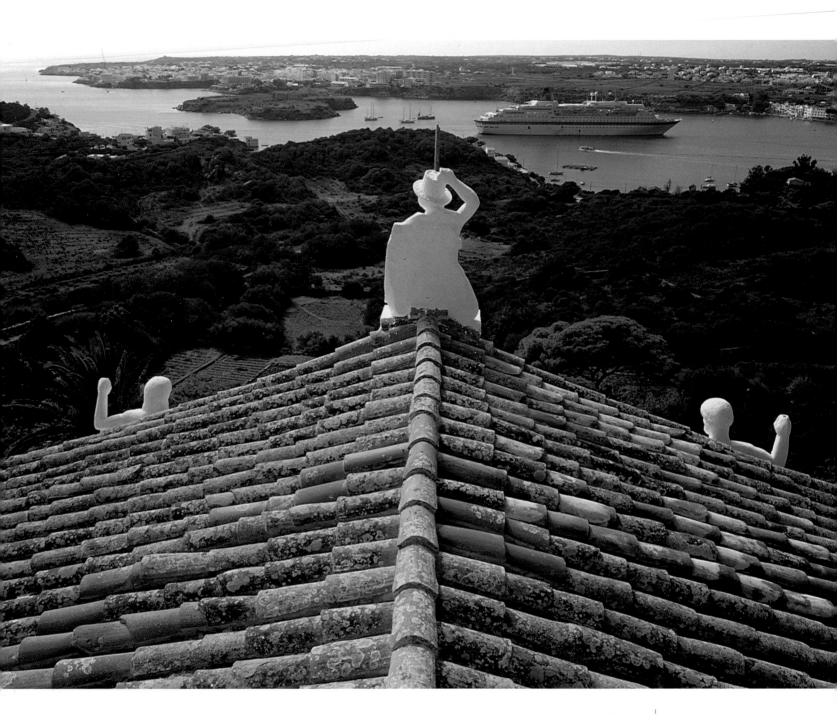

The roof of the "Golden Farm" offers a
panoramic view of the port of Mahón.

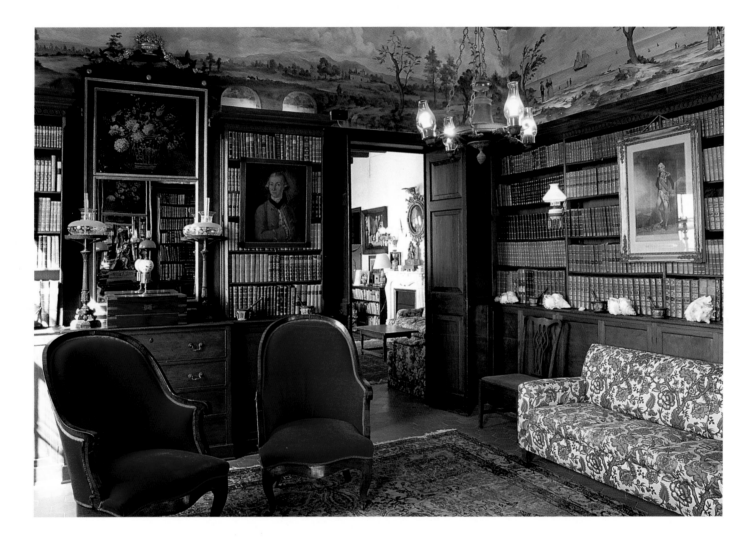

Historians aren't all that sure that Lord Nelson really lived at the Golden Farm, but the house (privately owned and not open to the public) is filled with exquisite English furnishings and contains much Nelson memorabilia. The current owner, himself British, is writing a history of the house.

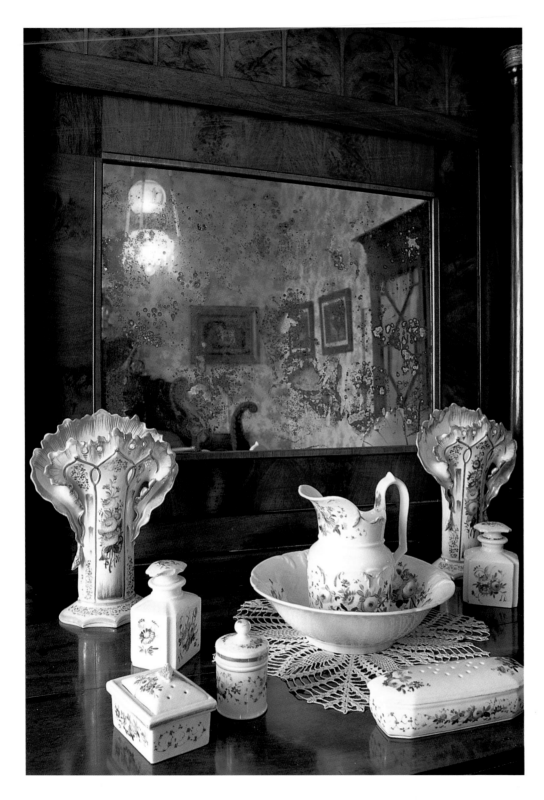

Did Lord Nelson and Lady Hamilton share this bedroom? Probably not.

left: Artifacts from the Nelson era at the Golden Farm.

Cisterns collect precious rainwater for houses all over the island. A large one supplying an old *finca* (complete with defense tower) near Monte Toro suggests a man-made crater on its barren hilltop. Smaller cisterns are found on the rooftops or in the patios of many private houses.

A typical Minorcan gate leads into a landscape that suggests Cornwall or Wales.

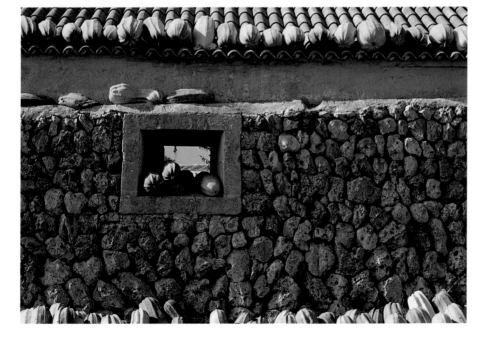

In rural Minorca, food is still preserved in traditional ways. Here, squash and melons are drying for the winter.

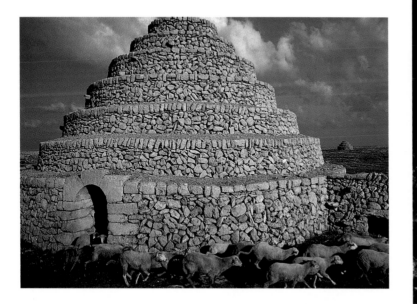

These stone *barracas*—shelters for sheep and other farm animals—near Ciudadela are based on an ancient design. Similar structures are found in southern Italy and elsewhere around the Mediterranean.

right: This *taula*, or religious monument, and the adjacent *tayalot*, a fortified watchtower and dwelling place, at Binissafullet (near San Luís) date from as early as 1500 B.C.

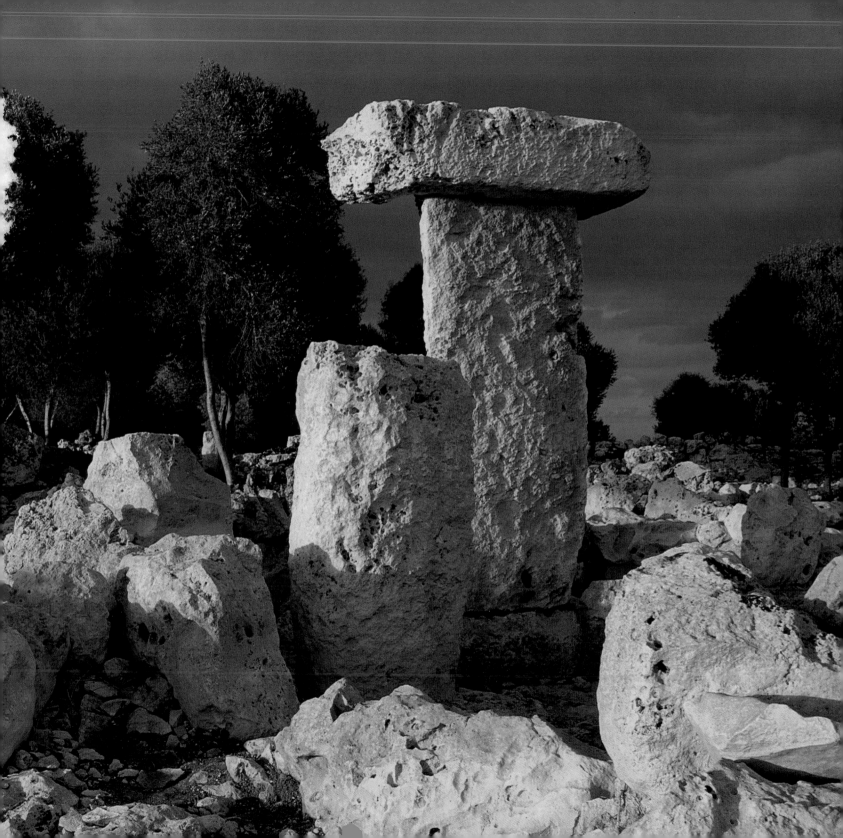

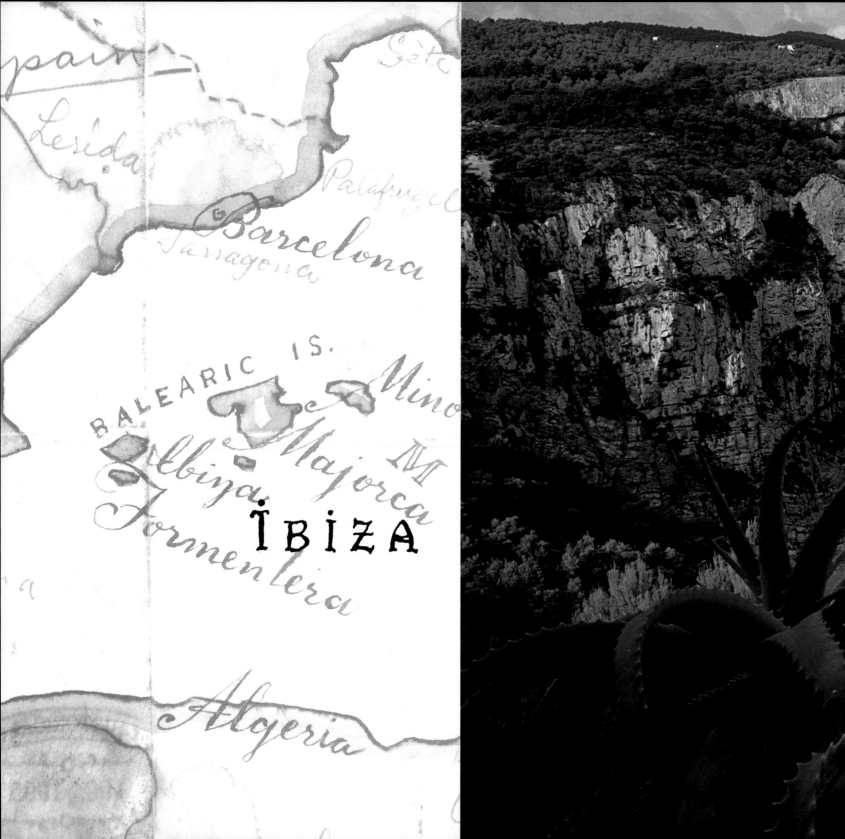

ÏBÏZA

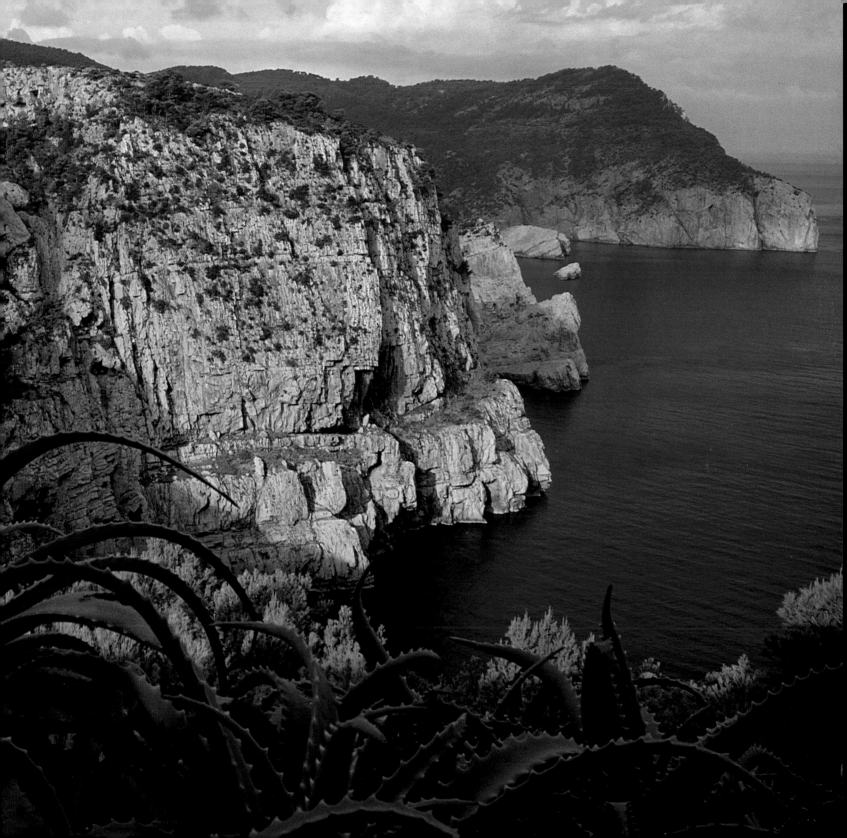

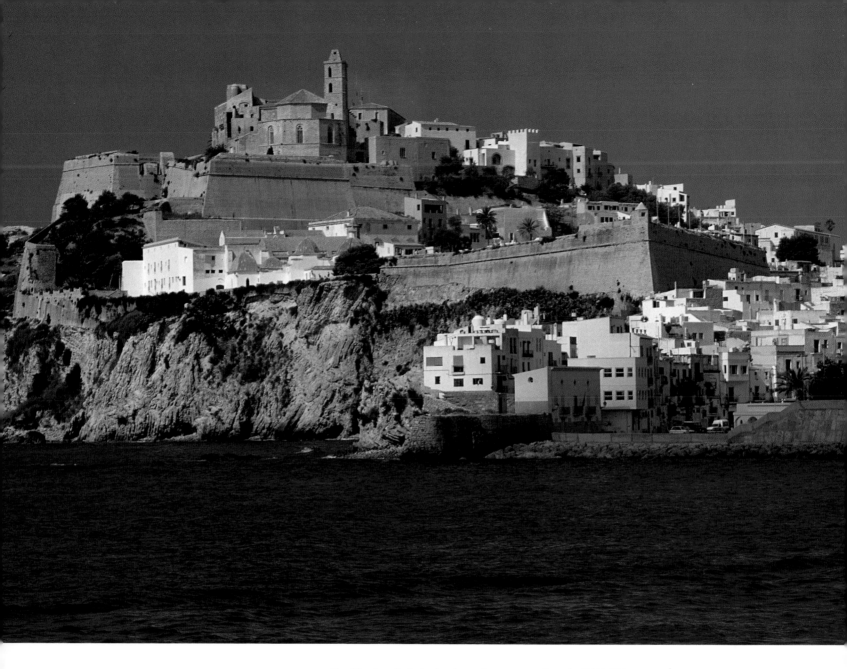

Fortifications built in the sixteenth century enclose the D'Alt Vila, or
Upper Town, rising above the rest of the town of Ibiza. This is the view
from one of the boats that plies the route between Ibiza and Formentera.

\mathcal{L}ike the Costa Brava on the nearby Catalan coast, Ibiza is a place both lovely and brassy, both sublime and ridiculous. On one hand, it is arguably the Mediterranean's most famous (or notorious) party island. Here you'll find huge, frenetic discos, vast nude beaches—one of the early Greek names for Ibiza, it has been noted with amusement, was Illa Gimnèsia, or the Island of Naked Men—non-stop beer-gardens, and tacky souvenir shops spilling out into the street selling T-shirts, cheap jewelry, and incense. Sleep, sun, eat, drink, sun, drink, eat, drink, dance, drink, sleep (with sex interspersed as often as possible)—that's the typical summertime routine here, at least for the young (or would-be young) and uninhibited.

On the other hand, Ibiza is richly sensual in other ways, full of quiet corners of great rural beauty. An oval-shaped island, it is crisscrossed with lines of steep hills leading down to the sea on all sides—sometimes dropping off with great bravado in the form of sheer, jagged cliffs and sometimes just sloping gently, almost lazily, into the water, forming calm little *calas*, or covelets. Stands of pine trees perfume the air; at one point, the Greeks called Ibiza and its close neighbor, Formentera, the Pityusae, or Pine Islands, for the dense pine forests that once covered them—though these were depleted hundreds of years ago, their wood gone for shipbuilding. Off the tourist track, small farms and market gardens grow grapes, olives, corn, figs, prickly pears, almonds, carob, hemp, and flax. Fragments of Roman roads lead into ancient olive groves.

The town of Ibiza, as the island's capital is also called, is unexpectedly lovely. The walls that enclose the so-called D'Alt Vila, or Upper Town, are a rare and fine example of sixteenth-century Spanish military architecture. Within them, surrounded by a warren of tortuous medieval streets, are a huge Gothic cathedral and a small but fascinating archaeological museum. The Spanish government has recently declared the D'Alt Vila a national monument, and with help from the European Community, it is restoring and sprucing up the quarter.

preceding pages:
The terraces at the Hotel Hacienda near San Miguel afford a stunning view of the jagged coastline, the quiet coves, and the opulently blue sea on Ibiza's northern coast.

Downhill from the D'Alt Vila, the old fishermen's quarter called Sa Penya, or The Cliff, is more a maze than a warren, a barrio of what one Spanish guide calls *callejuelas impenetrables*—impenetrable alleyways. The Avenida Andenes, which runs along the port in front of Sa Penya and the adjacent (and more accessible) Marina district, is the lively social center of town, full of cafés and bars. Its continuation, the Paseo Vara de Rey, is a lovely, if not always peaceful, elongated square, with cafés under the colonnades. Here, and especially at the café on the ground floor of the 1930s-vintage Hotel Montesol, many Ibizencos and their holiday guests start the day with coffee—at four in the afternoon, or so.

Ibiza's traditional houses, pure and simple in design, are one of its greatest cultural treasures. The typical Ibizenco dwelling is a concatenation of cubes, whitewash-white—almost blindingly so in full sun—with a few small windows facing the exterior and several doors opening onto an interior courtyard or large central room. The tallest portion of the house usually faces south, so that the sun's rays can be caught from a high angle and spread through as much of the interior as possible. The roof is flat and rimmed with downward-slanting culverts leading to a cistern for collecting rainwater—drought being a constant threat here. The larger homes have covered porches, or *porxades*, providing shade and well-ventilated space for drying fruits and vegetables. The Belgian architect Philippe Rotthier, a specialist in traditional Ibizenco architecture, calls this kind of house *le palais paysan*—the peasant palace—and has demonstrated how every measurement, from roofline to width of door, is based on the human scale.

Not all houses on the island are so pure and simple, of course. Ibiza is a live-and-let-live island—the locals seem accepting of almost any kind of behavior as long as it doesn't affect them directly—and foreign residents often build expensive and extravagant homes for themselves, setting the stage for their own fantasies in this most agreeable of natural theaters.

Ibiza's hospitality has traditionally been extended to visitors of slender means as well as to wealthy ones, and the island has been a regular stop on the "hippie trail" since the 1960s. There's even still a weekly "hippy" (*sic*) market on Punta Arabí, near the beach town of Es Caná. Some residents of Ibiza seem to finance their stays on the island with their appearances here, selling fabrics, artwork, and other artifacts gathered on trips to Africa and Asia. Somehow it all seems to fit.

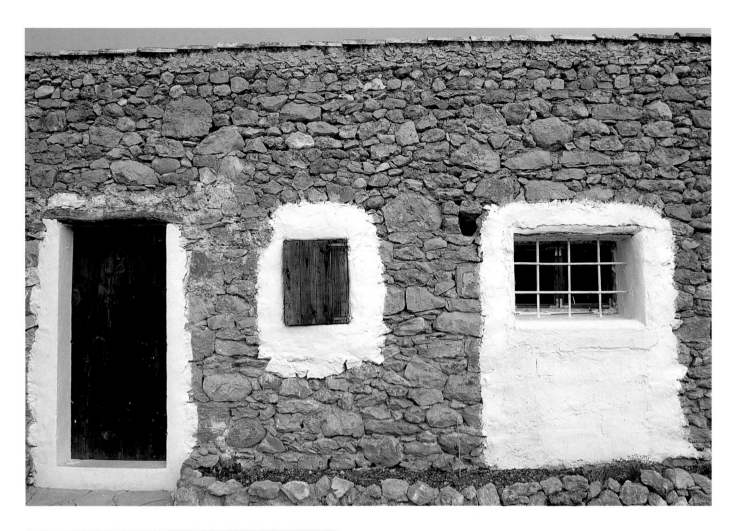

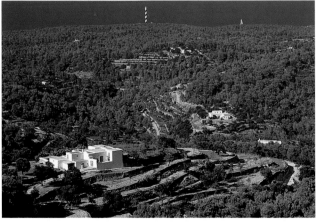

above: Whitewashed stucco window frames set into stone houses, as at this *casita* near Balafia, are a typical feature of Ibizenco architecture.

The wooded slopes between San Juan Bautista and Portinatx, on Ibiza's northern end, are one of the most beautiful—and unspoiled—portions of the island.

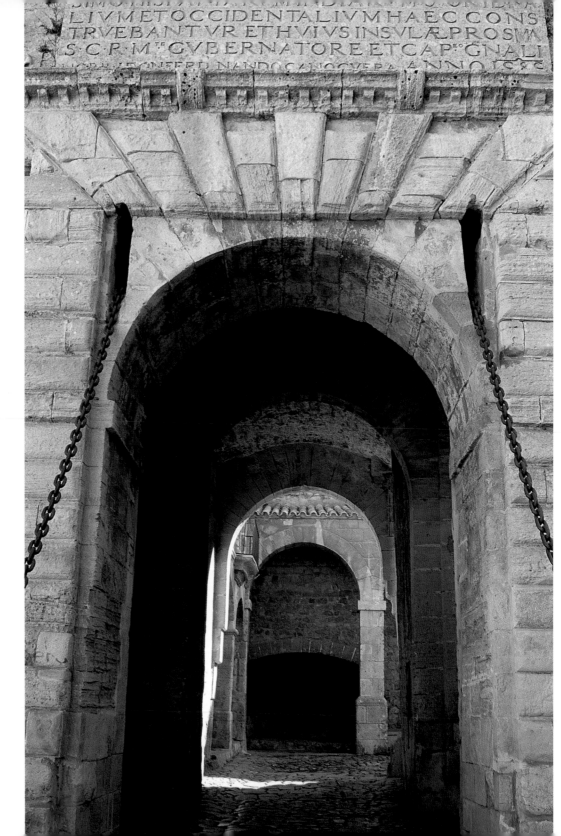

Arches inside one of two main gates into the D'Alt Vila (Upper Town), the Portal de las Tablas, form an appealing enfilade. The gate is named for slabs of stone that once made up its drawbridge.

The bright little Hotel La Ventana in the D'Alt Vila is simple but well kept, and
its rooftop patio offers unparalleled views of the lower portions of the town.

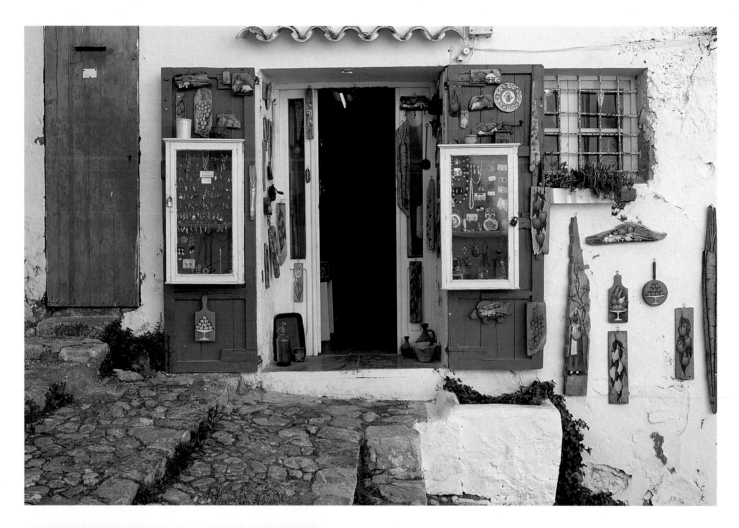

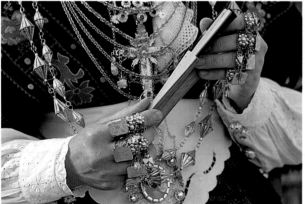

The narrow streets and tiny plazas of the D'Alt Vila are lined with restaurants and shops. Many shops sell jewelry and a mix of local and imported craftworks. Ibiza was famous in earlier times for its jewelry. Today, such ornaments are worn mostly for fiestas and folk-dance concerts.

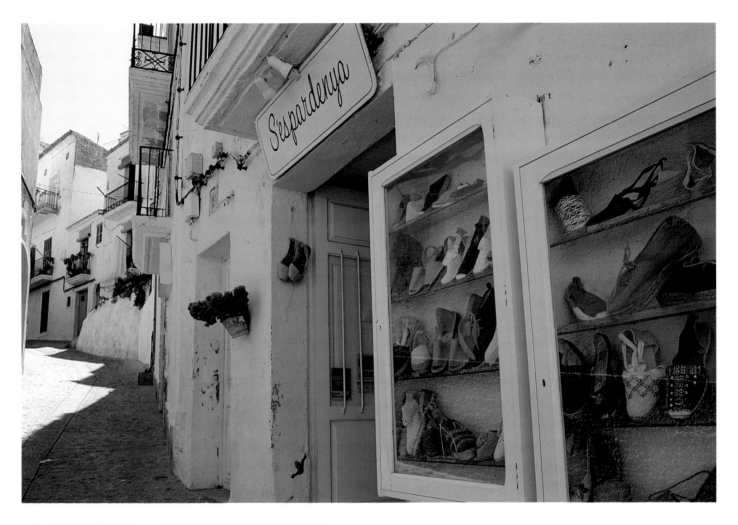

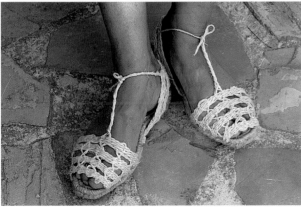

Other shops are more specialized, selling such products as ceramics and rope-soled shoes, or *espardenyes*. Traditional crafts, like the handweaving of these rope sandals, are still practiced on the island.

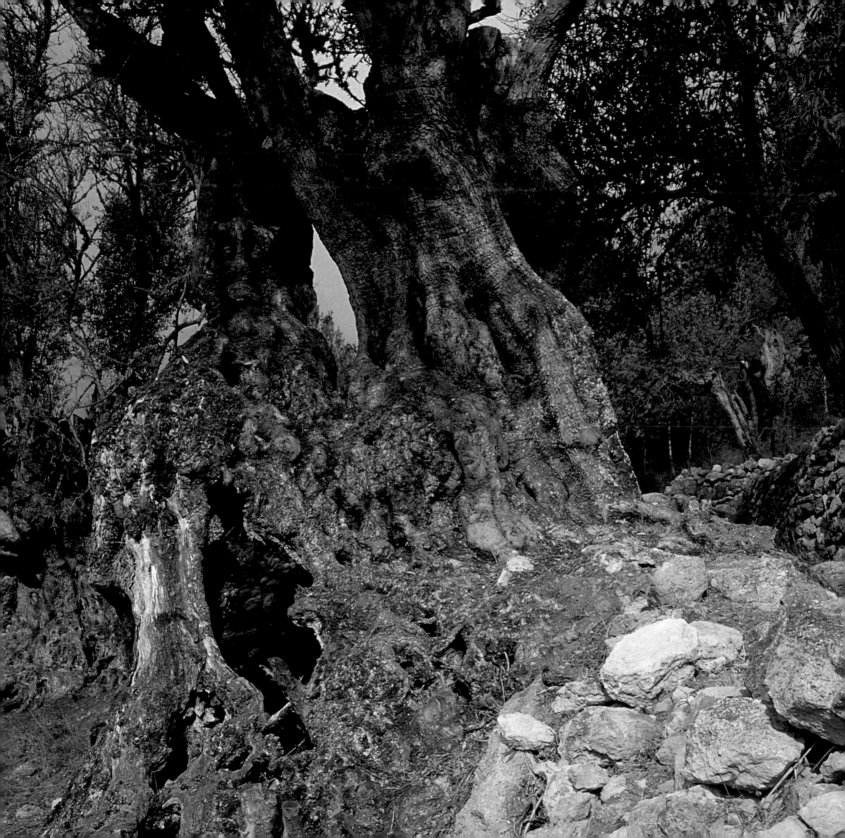

Horsedrawn carts, like this vivid blue one
on the road near San Juan (Sant Joan), are
still seen on Ibiza's little highways.

Centuries-old olive trees, like these gnarled
ancients near San Lorenzo, grow wild on Ibiza.

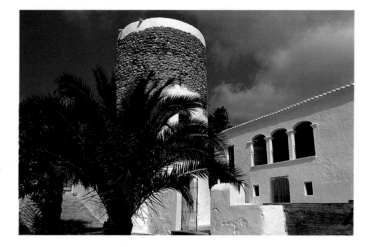

A timeworn stone watchtower is part of this local-owned house, one of the oldest on the island, behind the church at San Lorenzo.

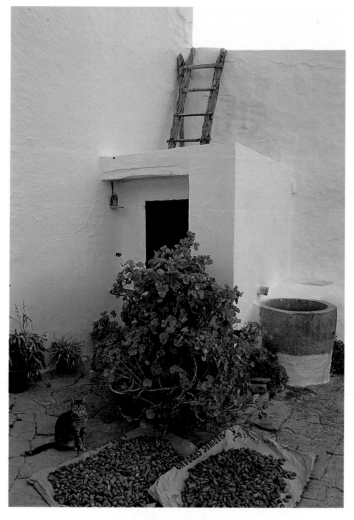

Outside a house in Balafia, almonds dry in the summer sun.

The round, brown stone Moorish tower at Balafia stands in marked contrast to the squared-off white houses of the town.

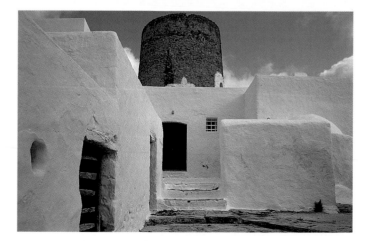

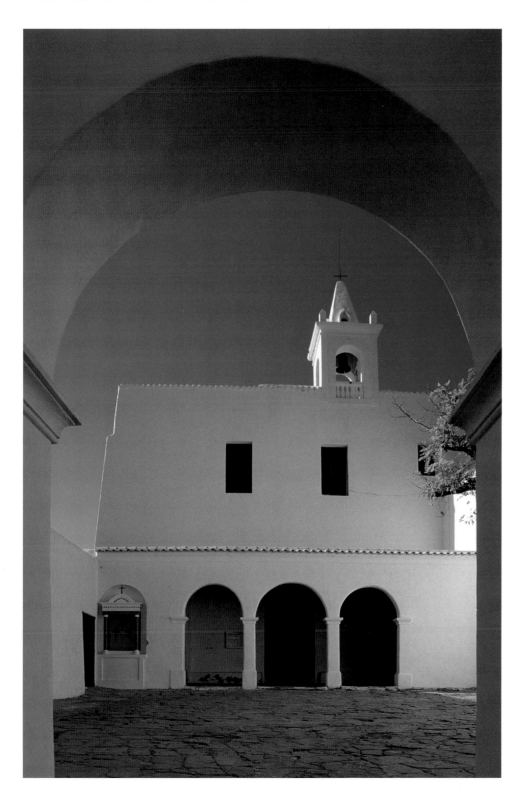

The church at San Miguel, built between the fourteenth and seventeenth centuries, formed the heart of one of Ibiza's first parishes. Despite its simple Ibizencan exterior, its interior shows influences of the Italian Baroque. Once a week during tourist season, traditional Ibizenco dances are held in the church courtyard.

The collection and recovery of rainwater is very important on this often-arid island. This beehive-shaped structure, which resembles the traditional Balearic bread oven in form, is a covered well above a cistern near San Miguel.

A South American painter lives in this classic Ibizenco house, with its arched second-story *porxada*, near Santa Eulalia del Rio (Santa Eulàlia d'es Riu) on the island's eastern coast.

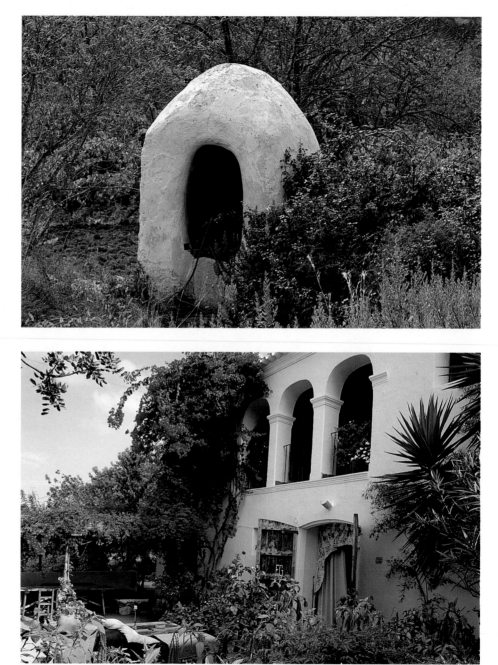

Ca'n Pau, a masterpiece of traditional Ibizenco architecture
near San Lorenzo, is unusual for its blue trim.

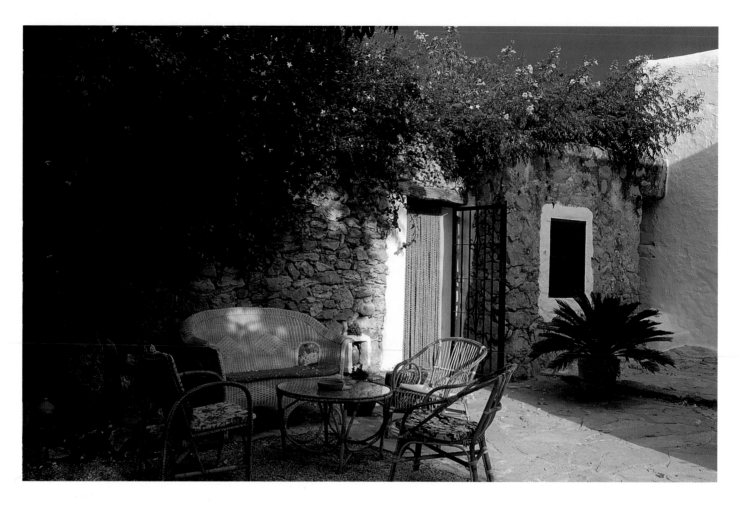

A German couple, proprietors of a water sports complex on the island, own
this handsome traditional house, Ca'n Cova, near San Lorenzo.

The blue wall conceals
a new bathroom added
to the guest quarters.

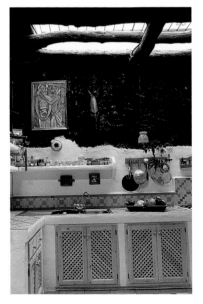

The cool, shaded terrace of the house is
a popular "room" in summer.

far left: The kitchen retains its traditional
shape and layout, but the roof has been
opened up to provide additional light.

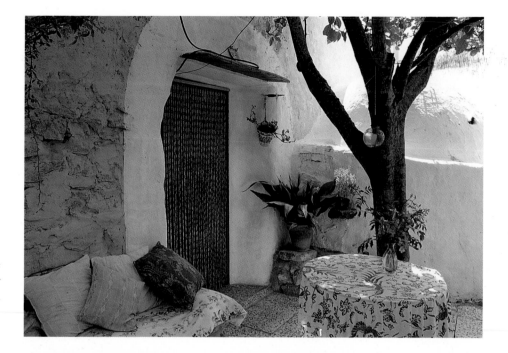

More indoor-outdoor living space on the terrace of this house near San Juan, Ca'n Pere Cala, owned by an artist from the Spanish mainland.

The artist has decorated the house with his own paintings and furniture as well as with Indonesian fabrics and other souvenirs of a well-traveled life.

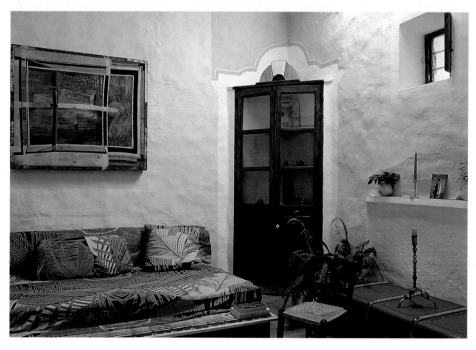

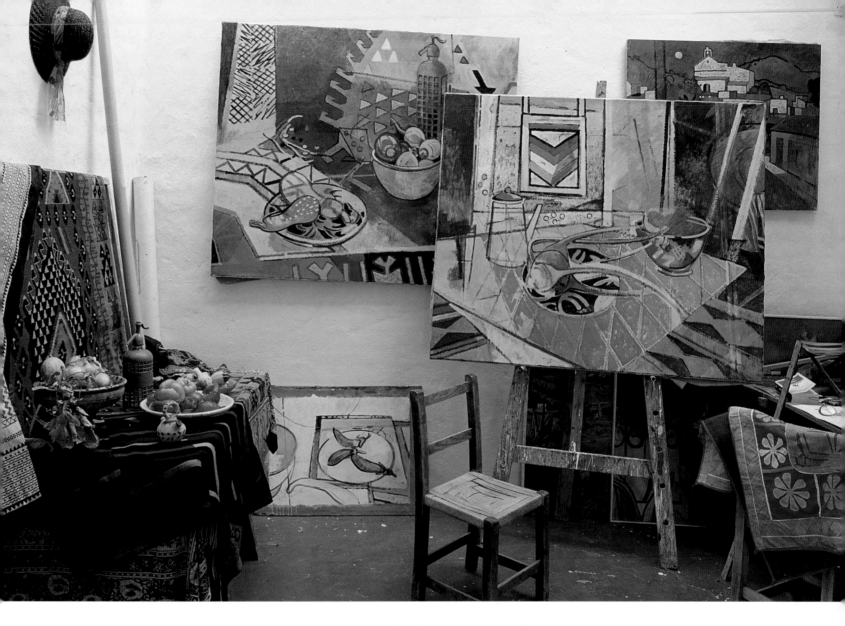

An American couple, both painters, who have been coming to Ibiza for a quarter of a century, spend half the year in this traditional-style house and the other half—quite a contrast!—in Iowa City. Paintings in the wife's studio betray the extent to which island motifs influence her work.

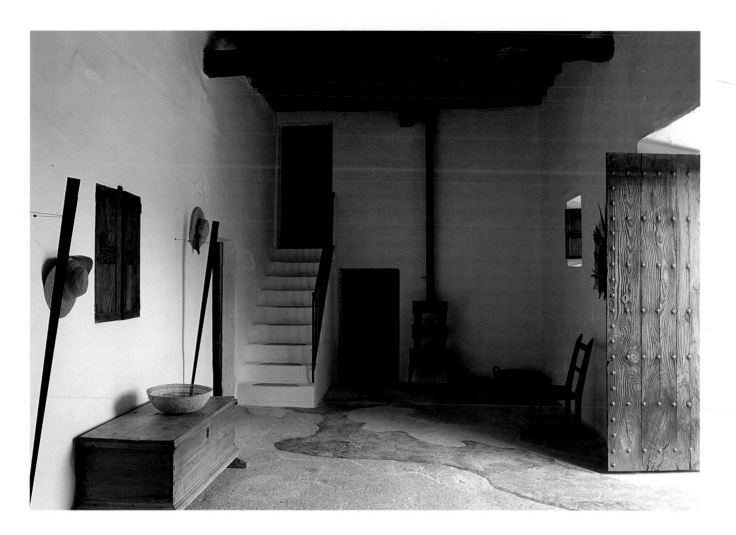

This is a traditional "sala" of Ca'n Lluqui, an old *finca* renovated by
Belgian-born architect Philippe Rotthier, perhaps the leading authority
on traditional Ibizenco architecture and design. The *finca* is located
in the hills behind San Carlos.

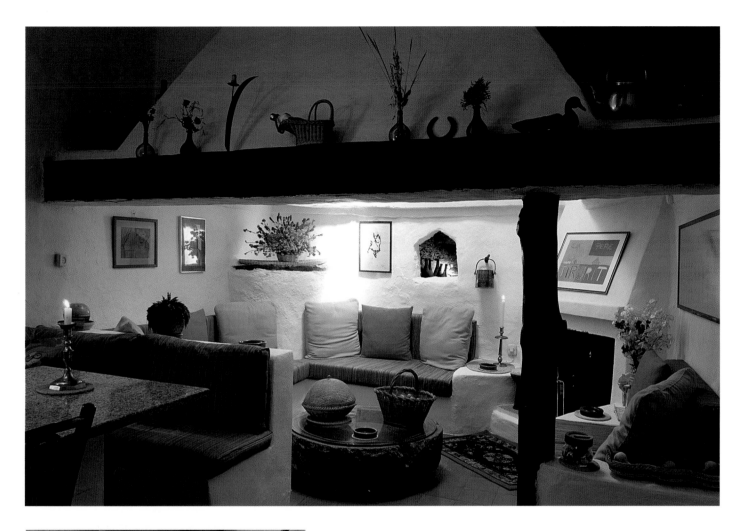

This kitchen in Ca'n Pere Tirurit is furnished with everything from Majorcan fabrics to oriental rugs to African-made furniture. An old Ibizenco oil press has been turned into a table.

A living area in Ca'n Lluqui, which was originally the kitchen and bread oven. Rotthier kept the house as close as possible to its original state and filled it with authentic Ibizenco furniture and crafts.

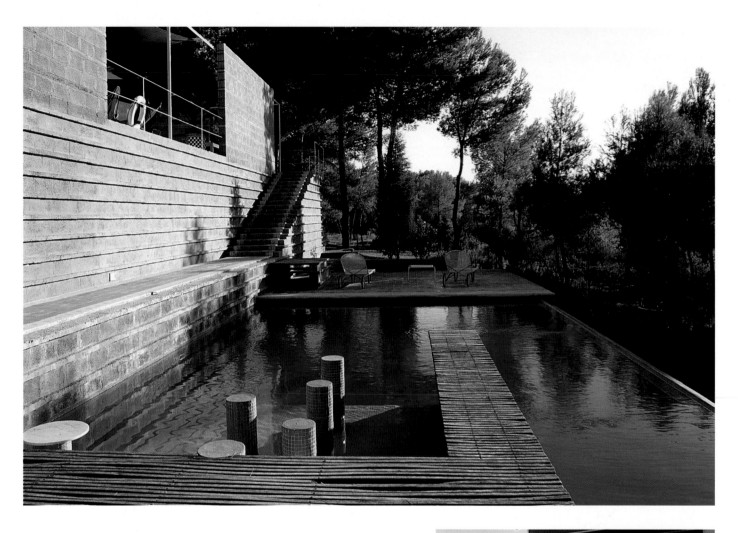

Internationally known Ibizenco architect Elias Torres
designed this contemporary style house near San Antonio.

Barcelona architect Victor Rahola restored and remodeled
this old *finca* near Jesús, a few miles from Ibiza town.
It is a textbook example of a fine traditional house with a
contemporary interior. Among imports from the Spanish
mainland are a Gaudí chair in the sitting room.

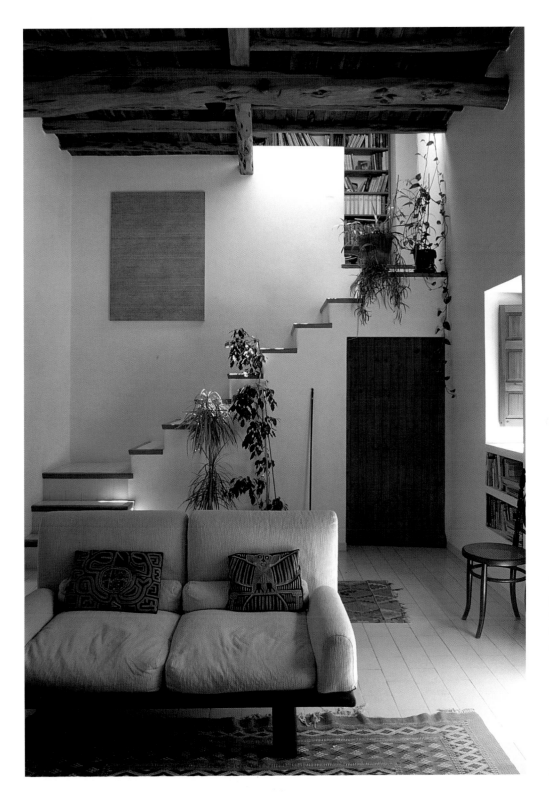

This new house, built from the ground up by Philippe Rotthier according to Ibizenco principles, is owned by a Belgian painter and his Ibizencan wife.

Rich red earth surrounds Ca'n Ribas,
an elegantly cleanlined house just
outside Santa Eulalia.

FORMENTERA

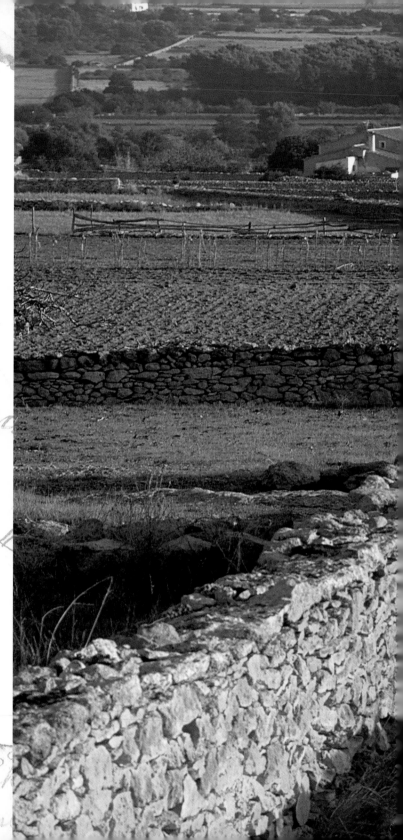

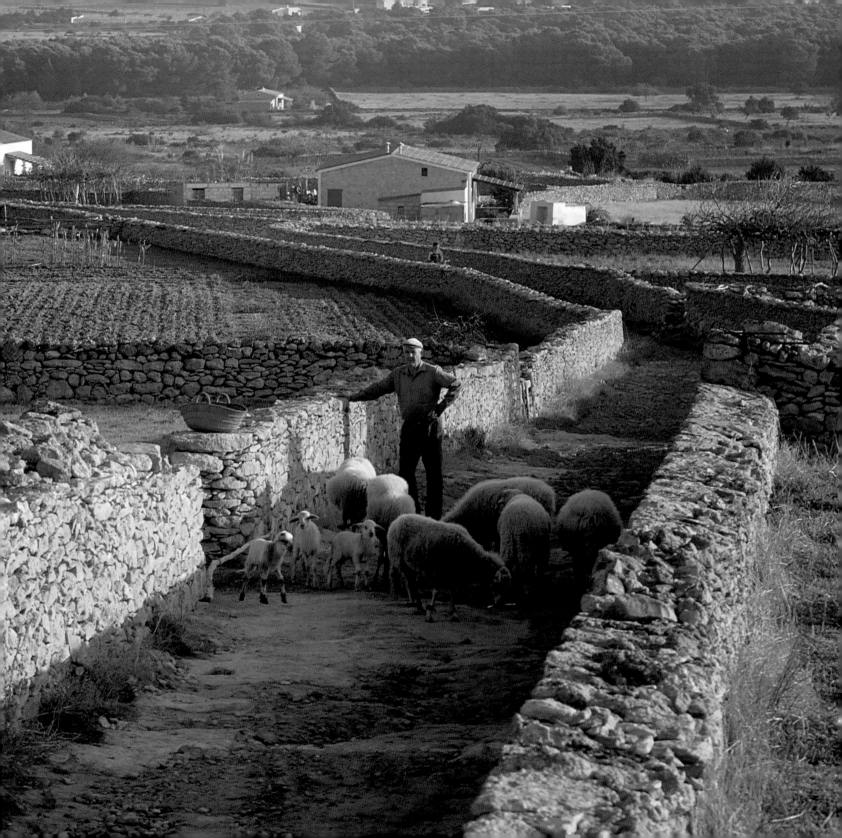

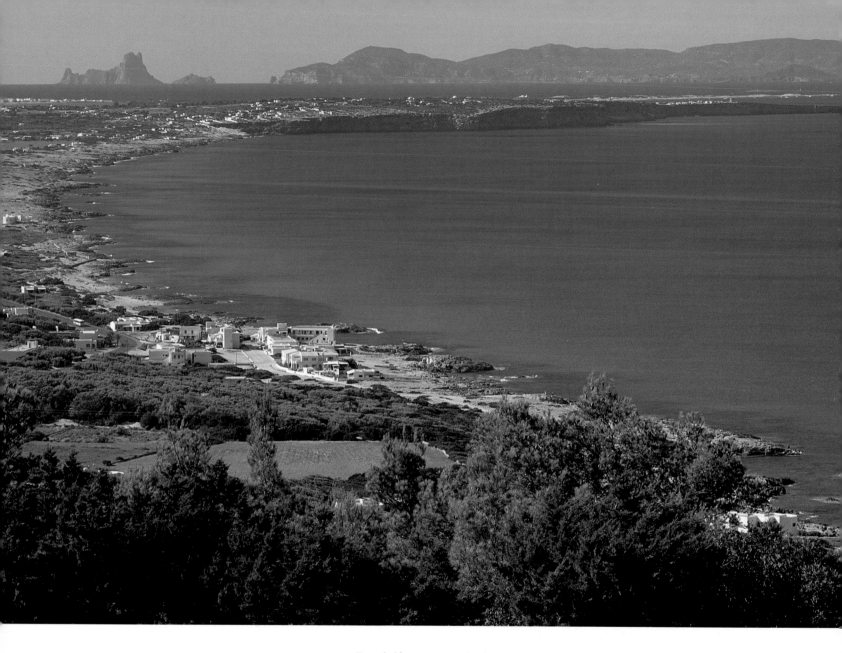

From halfway up La Mola, the mesa that occupies much of the
eastern tip of Formentera, nearly all the rest of the island, as
well as the islet of Es Vedra and much of Ibiza, can be seen.

Formentera is the smallest, least known, and most southerly of the Balearic Islands, lying three or four miles south of Ibiza and not all that far north of the deserts of North Africa. The island has a curious shape: if you tipped it upward to the west about 90 degrees, it might resemble a cartoon dinosaur, seated on its haunches, as seen through a mist. It also has a curious history: though it was inhabited as early as 2000 B.C., its population fled en masse in the fifteenth century before an onslaught of pirates, and it stood virtually empty for nearly three hundred years, until it was repopulated by settlers from Ibiza. It retains close ties with that island, as its proximity might suggest, and it has been said that some old Ibizenco traditions are better preserved today on Formentera than on Ibiza itself.

The island's name derives from the Latin word *frumentum*, or grain—which suggests that it was once known for its fertile farmland. The Greeks gave it its first recorded name, though, which was rather less complimentary: Ophuiussa, Isle of the Serpents. The Romans concurred, dubbing it Colubraria, which means approximately the same thing. According to legend, every sort of venomous animal could be found on the island. This is rather curious, since the truth is that no snakes or other poisonous creatures are found on the island at all; that rustling in the wild grass is likely to be one of Formentera's ubiquitous verdigris-green lizards, thoroughly harmless.

Much of Formentera's interior stands nearly barren, covered with wiry scrub, enlivened here and there by bright rockroses or poppies, and lightly framed by occasional pine woods. But there are still some farms and market gardens, mostly down the island's central core, growing wheat, almonds, carob, a few olives, grapevines (the local red wine is surprisingly good), and figs. These figs, appreciated by the Romans (and exported to Rome), are Formentera's particular pride—and one marked feature of the landscape is the broad, low, umbrella-shaped fig trees standing in the middle of yellow

preceding pages:
A farmer leads his sheep down a typical Formentera walled road on the Cap de Berberia early one morning.

left: Figs trees are everywhere on Formentera, producing as many as thirty different varieties of the fruit—to be eaten fresh and burstingly ripe or dried on rooftops and terraces. Dried figs are sometimes eaten as "sandwiches," stuffed with anise sprigs and thyme.

right: These traditional musical instruments, which are still played in local fiestas, were handcrafted by the late Pep Simón, a master woodworker.

fields, their fruit-heavy branches radiating out like spokes, and supported by staves. Beneath them, sheep and goats huddle in the shade.

On the island's western end, near its only port, La Sabina, saltpans and salty marshes stretch out, grayish-white and sometimes foamy, as if dosed with detergent. Nearby is the island's capital, the little village of San Francisco Javier. On the other end is Formentera's only "mountain," the mesa of La Mola, a green-and-brown promontory jutting out into the Mediterranean. Jules Verne mentioned this spot in one of his novels, and locals can point out a windmill on the mesa, one of the island's few, where Bob Dylan is supposed to have lived for a time in the Sixties.

Less celebrated foreigners come to Formentera, too, of course, and many of the island's houses are now owned by artists, architects, designers, and other creative types from all over Europe and America. Anyone looking for a "scene" (or for a larger canvas on which to splash life's colors) would probably do better in Ibiza, but those seeking privacy, peace and quiet, and the simple pleasures of sun, sea, and clear starry nights prefer this tiny island.

There are a handful of hotels, restaurants, and other facilities in the tourist town of Es Pujols and elsewhere near the island's beaches. But even at the height of summer, the touristic hordes—there is no airport on the island, but there is frequent hydroplane and ferry service from Ibiza—seem to affect the island hardly at all. Everything is very casual on Formentera, very low-key. Visitors stroll or bicycle down the narrow roads or bump along in dusty little rental cars, stopping here for a picnic, there for a dip in the cool, clear, seductively inviting water that surrounds the island. Bathing suits are optional; it's no big deal. Nothing on the island is, really, which may be its greatest charm of all.

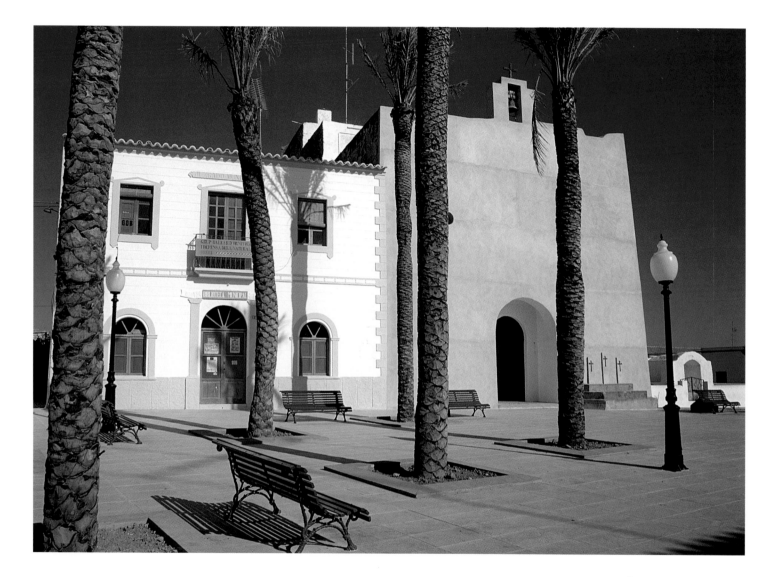

The eighteenth-century church in San Francisco Javier
(Sant Francesc Xavier), the island's tiny capital, is fortified
and windowless. Next door is the municipal library.

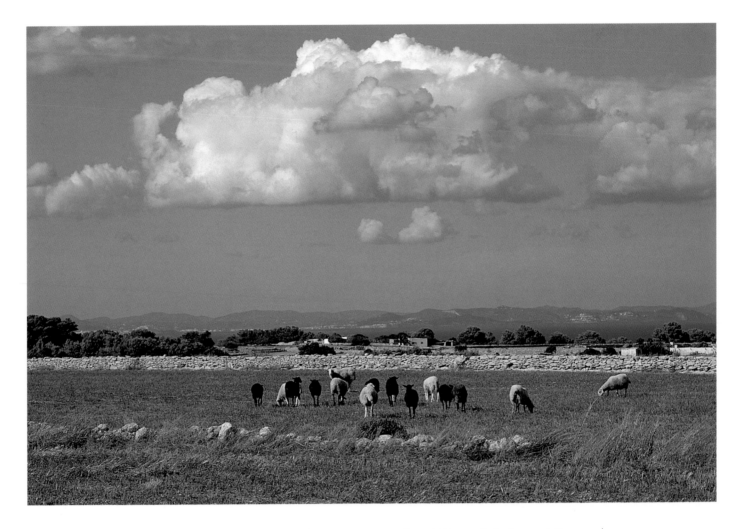

Sheep graze on La Mola, with Ibiza in the background. On a clear day like this one, Ibizan towns (in this case, Santa Eulalia) can be seen in detail from Formentera.

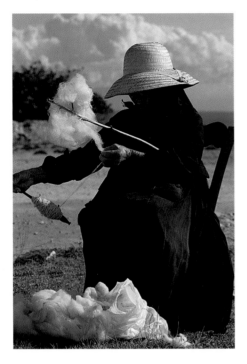

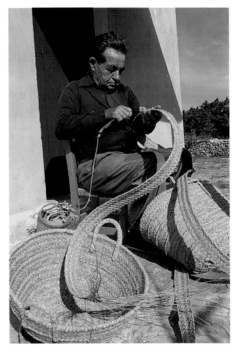

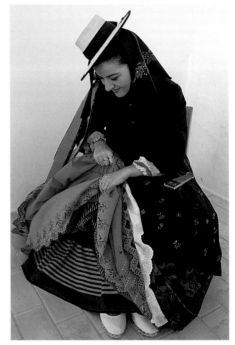

There are many sheep on Formentera, and until fifteen or twenty years ago, wool spinners like this one were a common sight. Today, only a few are left. Attractive hand-knit sweaters are still made here, but the wool is imported from the mainland.

The last old-style basket weaver on the island uses sturdy *esparta* grass imported from mainland Spain for his creations. He tried to teach his art to a younger craftsman, he says, but the man's hands were too weak.

The most beautiful fabrics in local traditional dress are used for the slips under the outer garment. The closer to the skin, the more elaborate the embroidery. The many layers were supposedly originally designed as protection—to safeguard a woman's modesty, and possibly her virtue.

A local woman in traditional dress—the everyday version, not a fancified fiesta get-up—picks fruit from a fig tree, its spreading branches supported with staves to form an umbrella of shade. The daily wearing of traditional garments has all but disappeared from the other Balearic Islands.

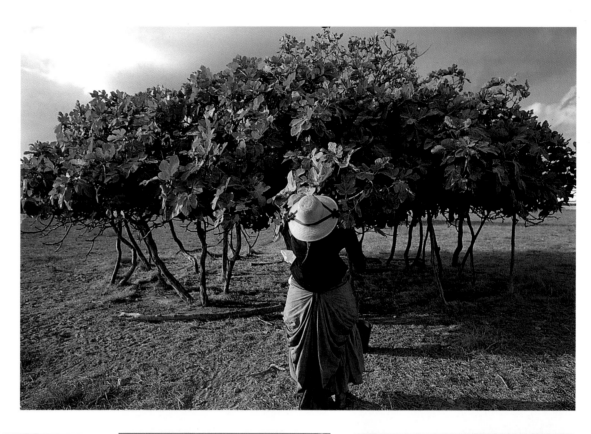

As elsewhere in the Balearics, tomatoes are hung to dry slightly in the breeze, not becoming dark and leathery like Italian dried tomatoes but retaining their form and juice.

far right: The bounty of a small island: *Higos chumbos*, or prickly-pear figs, are not real figs but edible cactus fruit (delicious chilled) that have sunny yellow blossoms and are ubiquitous on Formentera.

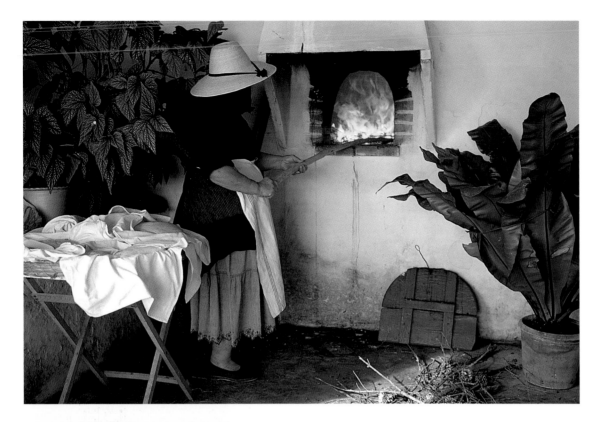

Many *fincas* on the island still have traditional bread ovens like these, in which bread is baked weekly.

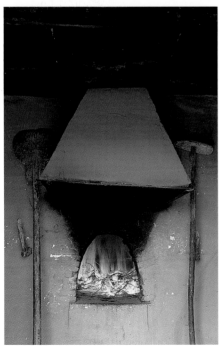

Most houses on Formentera are white, ochre, or stone-brown—but occasionally, as with this one on the Cap de Berberia, bright colors appear. Geraniums, which grow well on the island, add vivid contrast.

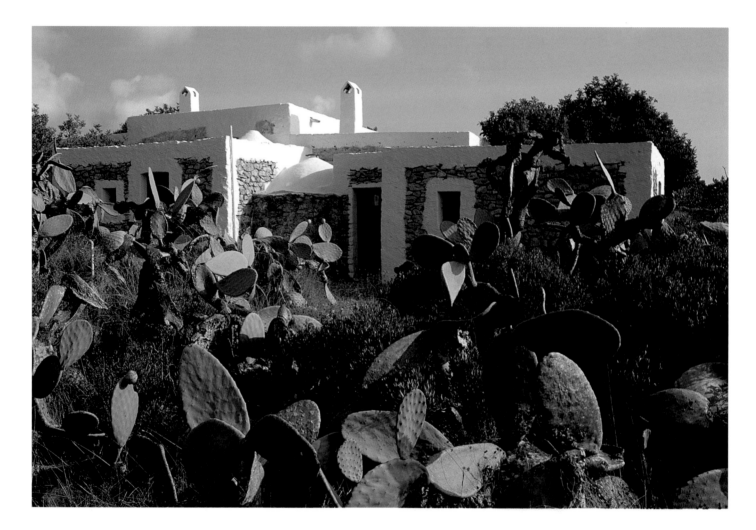

Higos chumbos surround this stone-and-whitewashed-stucco house,
owned by a French couple, on the Cap de Berberia.

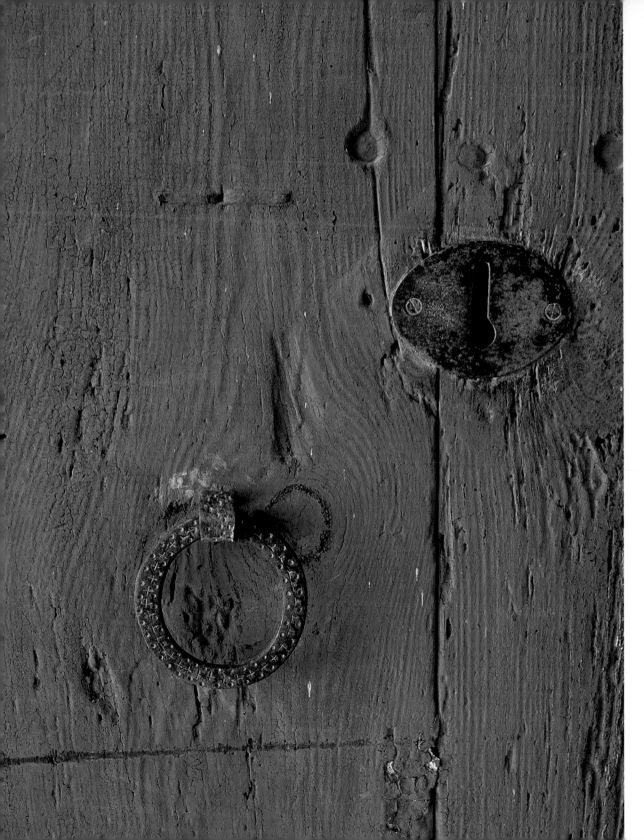

Local iron work is often beautiful as well as functional, as with this antique lock and door handle.

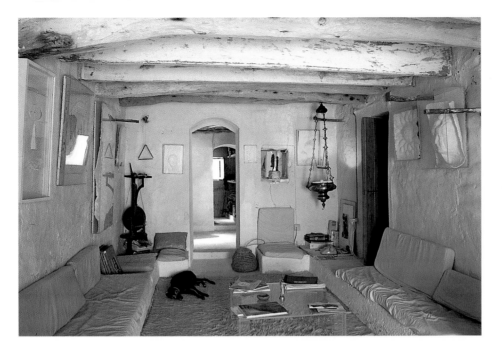

Two French artists, who live on Formentera half the year, have renovated this old house in the middle of the island. The ceiling beams are of savin wood.

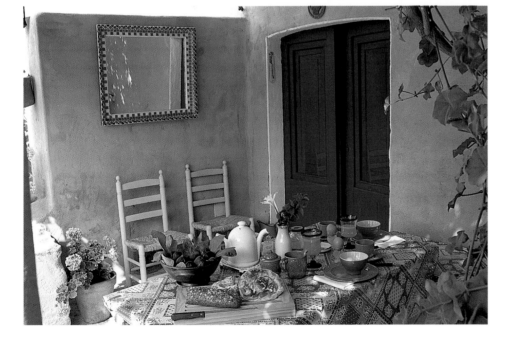

Outside the electric-blue doors of this renovated farmhouse on the Cap de Berberia, a French theatrical actor and producer and his wife have set the table for breakfast.

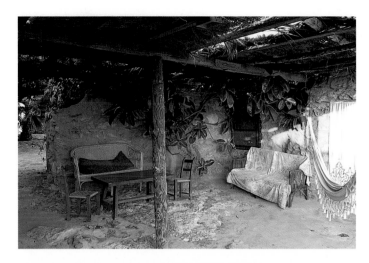

One of the most imaginatively renovated houses on Formentera is this one on the Estany Pudent, owned by a noted Catalan painter and his French wife. Outdoor living is the mode on the island, either in the sun or shaded by thatch.

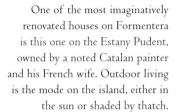

The bathroom, remodeled from an old *corral,* or animal pen, includes a *pique-assiette* shower.

The rug in the entryway is woven from *esparta* grass.

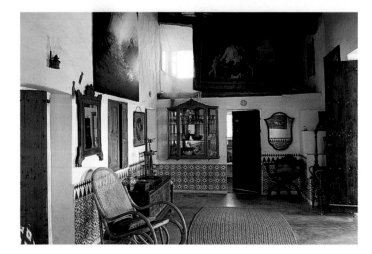

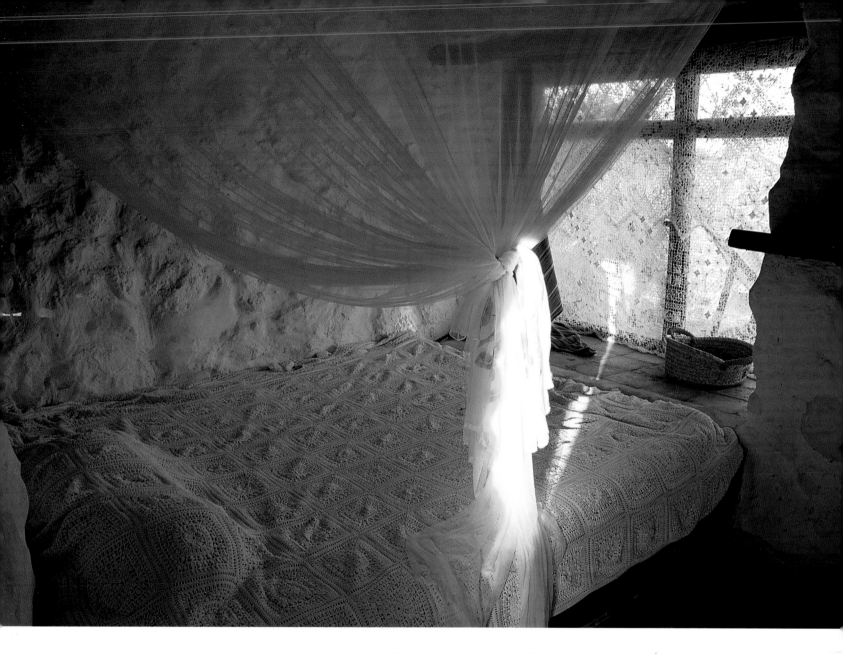

Mosquito nets are common in Formentera bedrooms.

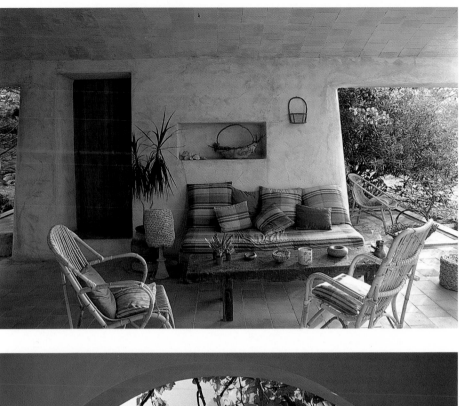

A French architect designed this new house for two French radio producers.

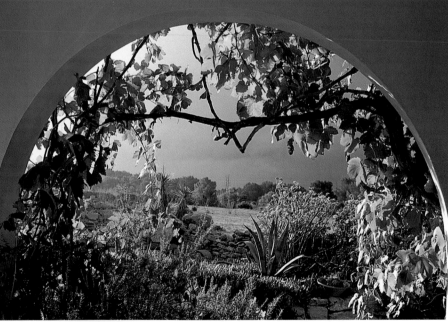

Seen through the archway at a *finca* on La Mola, a typical Formentera landscape—patches of barren ground defined by fieldstone walls and pine woods—seems to glow between raindrops on a stormy day.

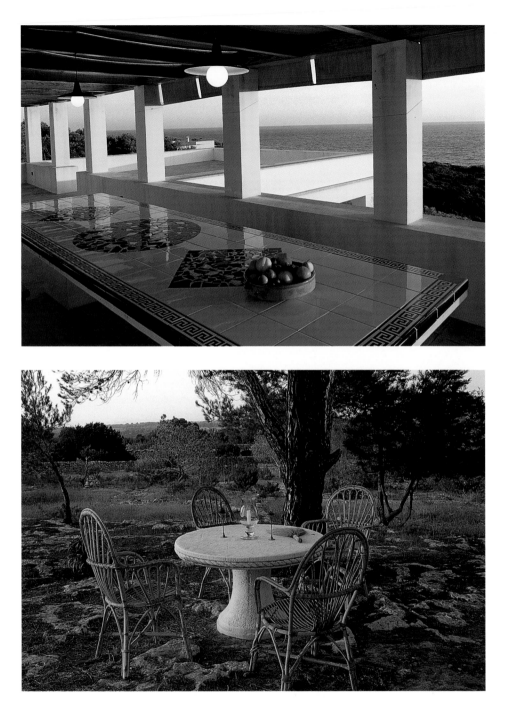

An Italian couple, both clothing designers, live most of the year in this very contemporary house at Es Ram, on the southern flank of La Mola.

The owners of a house on the Cap de Berberia love to watch the sunset from this table near the edge of their property.

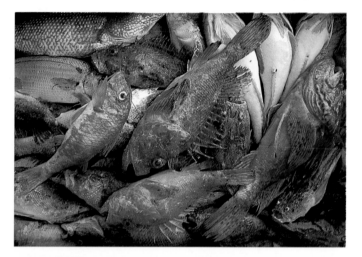

Fishermen still find the sea's delicious bounty
in the clear waters off Formentera—for instance,
these *salmonetes*, or red mullets.

Open-sided fishermen's *casitas*, like this one at
Estufador, protect the boats and offer cooling shade.

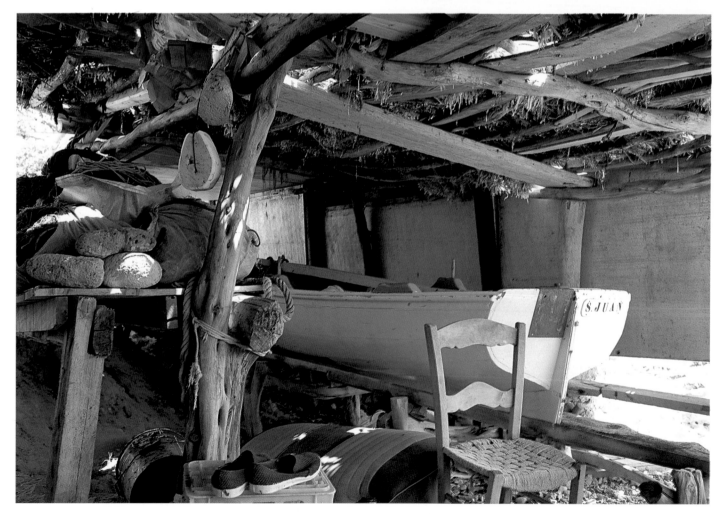

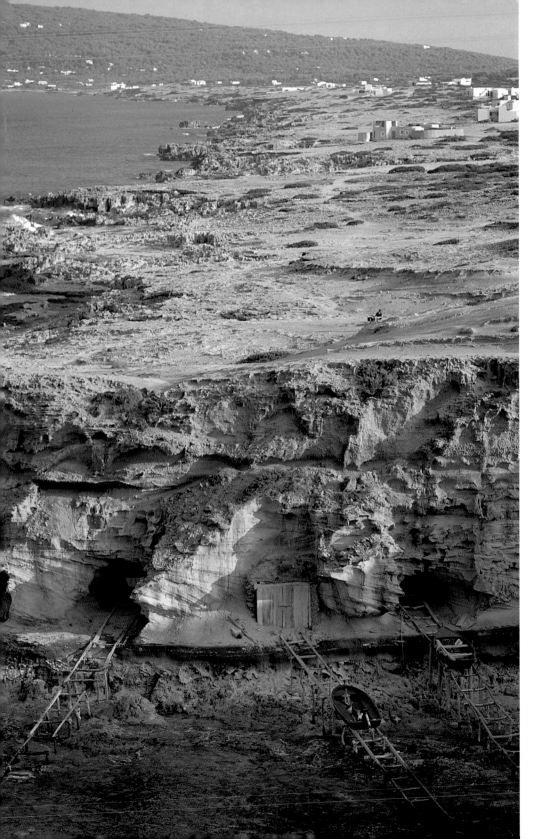

The jagged, pitted cliffs of Punta
d'es Picatxo are typical of Formentera's
dramatic, irregular coastline.

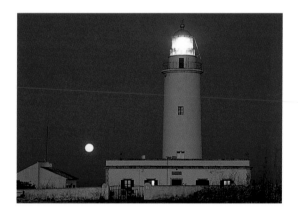

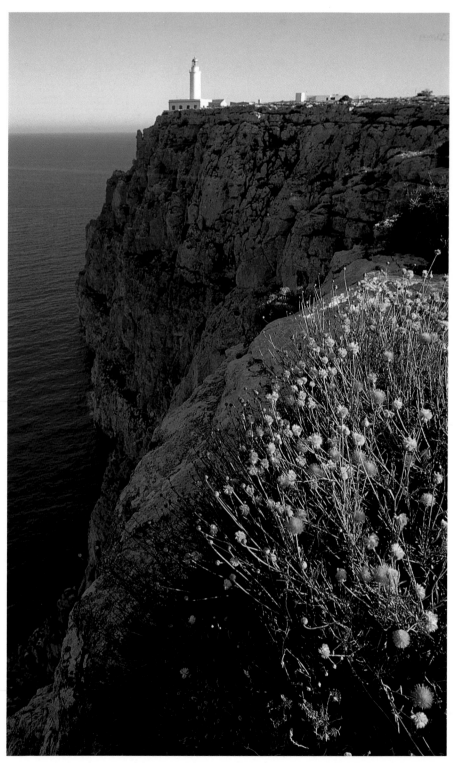

above: A full moon seems to reflect the beams from the La Mola Lighthouse—though in reality, the light has a range of only sixteen nautical miles.

The Faro de la Mola, or La Mola Lighthouse, dating from the mid-nineteenth century, stands on the highest point on the island, at the edge of the mesa.

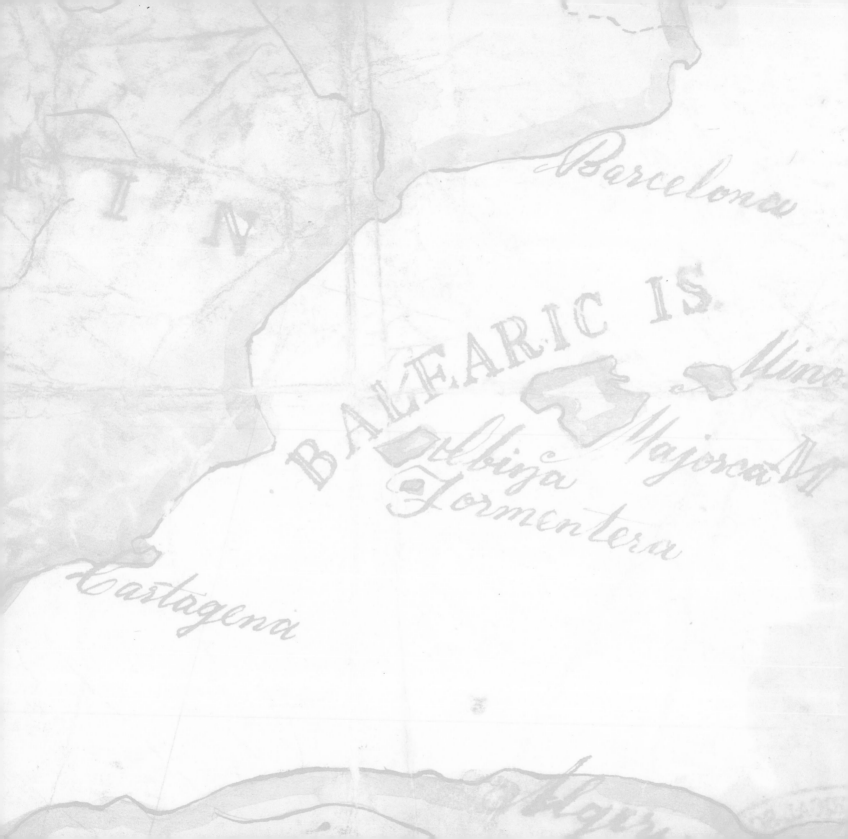